IMAGES OF WALES

AROUND
PORTH

VALLEYS

INVITATION OFFICE No. 042 CU

RHONDDA VISITOR'S
PASTPORTH

For Subjects of Hiraeth

"WE'LL KEEP A WELCOME"

VALID INDEFINITELY

(VALLEYS FOR EVER)

IMAGES OF WALES

AROUND PORTH

ALDO BACCHETTA AND GLYN RUDD

TEMPUS

Frontispiece: Dave Edward, Rhondda Leader Reporter receives the Rhondda 'Pastporth', 'I'm the proud owner of a Rhondda Visitor's 'Pastporth'. Retired steam pie baron Aldo Bacchetta granted me the Pastporth, which I am as pleased as Porthcawl punch to have. The Pastporth means I am now warmly welcomed in all realms of the Rhondda. Mind you, there are certain conditions with which I must comply, including no swimming in the Rhondda Fawr at low tide, no cycling up to Penrhys and no grizzling in public places.'

First published 2004

Tempus Publishing Limited
The Mill, Brimscombe Port,
Stroud, Gloucestershire, GL5 2QG
www.tempus-publishing.com

British Library Cataloguing in Publication Data.
A catalogue record for this book is available from the British Library.

ISBN 0 7524 2496 3

Typesetting and origination by Tempus Publishing Limited.
Printed and bound in Great Britain.

Contents

Acknowledgements

Thanks to Brian Davies MP, Ed Cloutman, Vivian Stitchcombe, Wilf Jones, Treorchy Library, Rosslyn Williams, Sarah Morgan, Margaret Rudd, Janet Collier, Anthea and Brian Davies, Denis Bradfield, Malcolm Griffiths, Ron Daley, Keith Edmunds, Glyn Howells, Mrs Green, Gwyn Harries, John Griffiths, Millie Watkins, Artro Evans, Mrs Moore, Mr Price, Gary Kingsbury, Percy Kingsbury, Mr R. Williams, Mair Bunyan, Martin Phelan, Gilbert and Shirley Hanks, Colin Williams, Dave Edwards, Viv Thomas, Des Burge, Anthony John, *Stanley Baker Filmography*, St Fagans Museum of Welsh Life, Colin Hughes (author of *Lime Lemon and Saspirella*) and Dave Edwards, Rhondda Leader.

Apologies to anyone we have failed to mention.

Foreword

This book rightly celebrates the achievements of Rhondda people. Gwyn Thomas, the writer and broadcaster whose career is outlined here, explained the driving force behind his own work in his last broadcast in 1981, 'I can still feel the great movement of people coming from many parts of the world into these two narrow gulches; the sense of energy, the sense of absolute despair, that so many human beings should have flooded into such narrow places.'

But although he grew up in the Rhondda of the Depression, Gwyn remained essentially an optimist, and this optimism grew out of his experience here. In his last public lecture in 1979, he reminisced: 'I marvel at my childhood. It was a comedy of menace and hope.' He drew inspiration from the way that 'such things were endured with such dignity, and such humour, such tenderness one for the other.'

We all need to know about our past to understand who we are, and to remind us of what previous generations have achieved may help us to do more. Aldo and Glyn have given us a book which will rekindle many memories, and perhaps encourage us to think about what we want for our communities in the future.

Brian Davies
Curator, Pontypridd Historical and Cultural Centre

Introduction

In our last three books, we have evoked the all-encompassing blackness the miners of the Rhondda Valley had to face when working underground; darkness that would only be pierced by the gleam of the lamps on their helmets as they lay on their stomachs beneath a ceiling of hundreds of tons of coal and rock just inches above their heads. Imagine hard enough, and you can almost smell the tang of the timber props, and hear the whispering of the forced air through the tunnels as they passed the air pressure doors. Then came the long, hard slog to the various working faces, men and boys heading towards the coal face with all its dangerous elements. Some tunnels were ankle-deep in clinging black sludge, but there was also fine dry dust present which would dance up as high as the beam on their helmets and drift into throat and nose alike.

So this was the Rhondda Valley and the black diamond heart of Wales that fed millions of tons of coal into the industries of Great Britain and the rest of the world. The collieries have all since gone, and now all we have left are memories and, for those families who have lost their loved ones, grief. In our fourth book, we have tried to capture the brave bold spirit of the strong miners, and also the people that created a vibrant community, working hard and playing to win. Included here are sporting memories (football and rugby), reminiscences about eisteddfods, and recollections of the teachers and the schools that produced many scholars. It is our duty to look back and remember the men and women that have helped to make the name of the Rhondda Valley famous around the globe. We dedicate this book to them.

Glyn Rudd and Aldo Bacchetta

Porth and the Hub of the Rhondda

Porth and Cymmer of Old

Dan Jones (Ex-Headmaster, Cymmer Schools)

History has no record of any notable person, nor of any outstanding event connected with the immediate surroundings of this district. In common with the rest of the two Valleys, it undoubtedly re-echoed in former days to the battle cry of Cadwgan of the Battleaxe, friend and supporter of Owen Glyndwr, and came under the benign influence of the religious fraternity assembled at the old monastery of Penrhys, but apart from these traditions, history is silent.

Nor can we say that excavations have brought to light the relics of prehistoric habitations, so beloved of antiquarians. No cairns or mounds have been found and their stone 'cists' or burial chests exposed, nor are there the sites of the approach of invading foes. All we can justly claim is that our district in olden days presented a scene of natural beauty equal to any other part of these admittedly wild and picturesque Valleys.

One writer, at the beginning of the last century, describes his impressions thus: 'The Rhondda makes fertile the valley with its clear, pure stream rolling over loose stones. For miles there is a luxuriance much beyond what my entrance in this district led me to expect. The meadows, rich and verdant, with the mountains the most wild and romantic surrounding them on every side, are the highest degree picturesque. The sides of the hills are clothed with a seemingly endless supply of woods'.

If our observer turned then to the hollow itself, he would obtain an unobstructed view of 'the meeting of the waters' at the foot of Penrhys, where the lesser stream says, as it were, to the bigger stream, *Cymer fi* ('Take me'), thus suggesting the name given to the district, 'Cymmer'. The name really means, according to the authorities, the junction of two rivers of the same name – in this case, the two Rhonddas.

Following the united streams in their course, their crystal clear waters sparkling in the sunlight, the green fields of Porth Farm would greet him on the flat to the left of the river, and those of Tynycymmer Farm on the rising ground to its right. Some distance below, on the site now occupied by the Imperial Hotel, used to stand the Eirw Farm. Joining the two banks, at the point where the cart track came to the river, was a bridge. On the farther side of the bridge the track divided, one branch turning up towards the valleys and the other towards Pontypridd: there was no Dinas Road in those days. Dotted here and there were a few other farm houses, namely Troedyrhiw and Llethr Ddu farms on the slopes of Penrhys, and Bedw and Glynfach farms, whence the sound of swishing scythes could be as the sturdy mowers bent to their task. The cattle grazing in the fields and the varied green of the vegetation completed the picture.

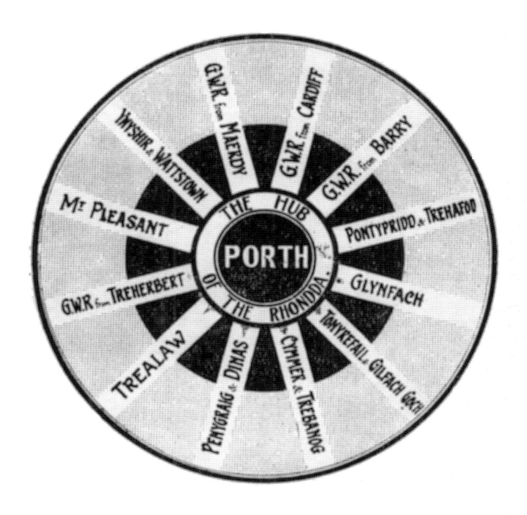

Promotional advertisement showing that all roads and railways lead to Porth, in aid of Empire shopping week in Porth, 1931. This was taken from the original souvenir programme.

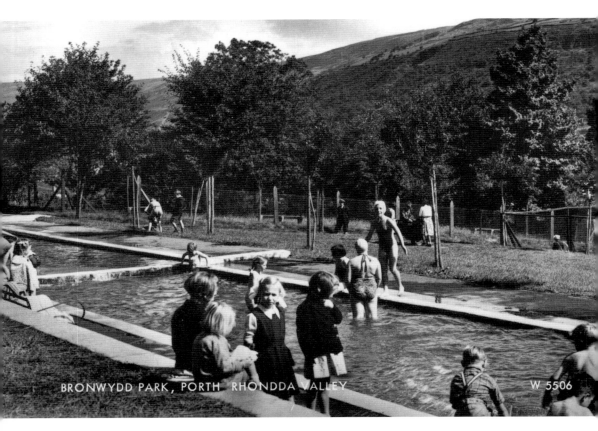

The old paddling pool, Bronwydd Park, Porth, *c.* 1940.

The rural character of the district was first affected when Mr Walter Coffin commenced coal-digging operations at Dinas around 1806. Later, he constructed a tramway from his colliery, along the route of the present Dinas Road and on to Gyfeillon (Hopkinstown) to join a previously constructed tramway, extending to the canal at Treforest. Along this tramway his coal was hauled until the opening for traffic of the Taff Vale Railway, as far as Dinas, which took place in 1840. The railway had been started in 1836, and with the development of collieries, was later extended to Treherbert and Mardy.

With the sinking of Cymmer Pit in the 1840s, and its gradual extension and development, the rural and sylvan characteristics of the area disappeared, and Porth assumed the dreary, godforsaken aspect of a colliery district. Fortunately, as Ceiriog said, 'Aros mae'r mynyddau mawr', and when the present-day dust and turmoil become unbearable, how pleasant it is to escape to the sweet air and deep silence of the mountain tops.

Thanks to the generosity of our respected townsman, William Evans CC, JP, Bronwydd, and to the Miners' Welfare Fund, we now have the beautifully laid out sanctuary of Bronwydd Park, with a paddling pool and a playground for the children, and tennis courts and a bowling green for adults, which considerably mitigate the drabness and dreariness of life to the inhabitants. Unfortunately, limited space precludes any reference to the customs and superstitions of these early days, and also to several well-known and eccentric characters, of whom many amusing stories are still extant.

Industrial Porth, Dan Jones

Although there is abundant evidence that coal and iron have been mined in the Rhondda Valleys from the earliest times, the work was of a spasmodic nature and on a small scale. What had been done, however, did not mar the sylvan beauty of our valleys for, as Malkin the traveller said in 1803, 'Such woods and groves as are rarely to be seen … A degree of luxuriance beyond anything I was led to expect.' From around 1790, the principal part of the coal used at Aberdare for household purposes was brought on horseback from levels at Trebanog, a distance of about twelve miles.

Shortly after this period, much progress was made in iron and coal mining in the Aberdare and Merthyr Valleys, developing gradually until the TVR was constructed from Cardiff to Abercynon (1839) to cope with the traffic. Yet Porth remained a tiny upland village, for a map of Porth in 1843 shows only twenty-five houses (including one chapel, one mill, and one inn) within a mile radius of Porth Square. In 1845 Cliffe, in his travels, writes of Porth: 'Exquisite effects peculiar to mountain scenery which a Claude could not transfer to canvas … Air aromatic with the wild flowers and mountain plants – a Sabbath stillness reigns. It is the gem of Glamorgan.'

One of the first coal pioneers was Dr Richard Griffiths of Pontypridd, who opened a level at Gyfeillon in 1790 and was so successful that he laid three miles of tram road to link up with the new canal at Treforest. In 1808 he leased the minerals under the Morgan Estate for ninety-nine years at a rental of £40 and 400 loads of coal per annum: sub-leases of this property proved very profitable to John Calvert, George Bassett, and the GWR Company.

At Dinas, just above Porth, another pioneer, Mr Walter Coffin, was prospecting for coal around the same time. In 1806 he leased the mineral rights under several farms for £40 a year. He worked the upper seams, which proved so profitable that in a short time he constructed three miles of tram road to join Dr Griffiths' tramway lower down the valley. Before the opening of the railway line at Pontypridd in 1840, he had sent 56,000 tons of coal from the Dinas Colliery by canal to Cardiff.

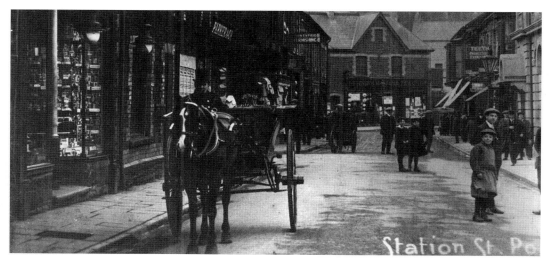

Station Street, Porth, with a hansom cab waiting for the arrival of the Taff Railway steam train from Cardiff, *c.* 1910.

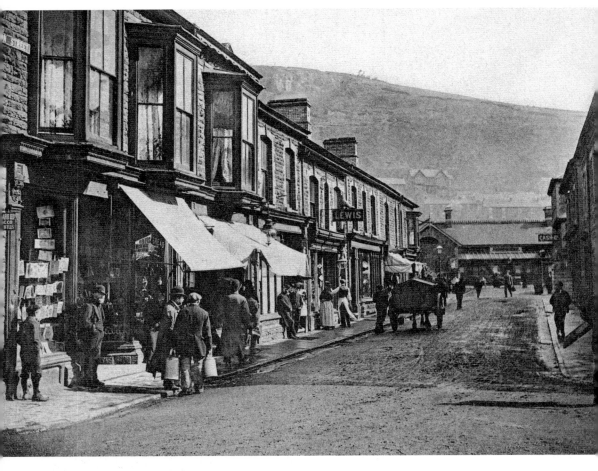

Station Street, Porth, showing the traders waiting for the early morning deliveries, 1910.

Opposite above: J. Humphries, Builders of North Road, *c.* 1910. The building is now occupied by Healy's the undertakers.

Opposite below: Plenty of bargains to be had in Hannah Street, Porth, *c.* 1920.

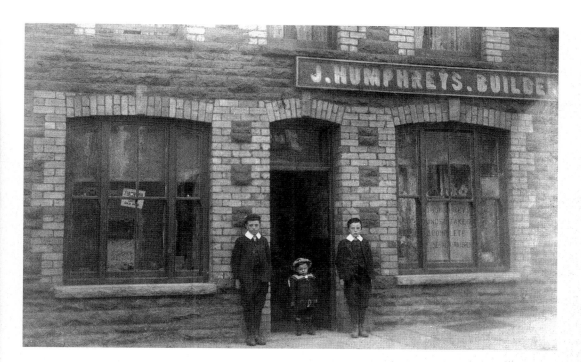

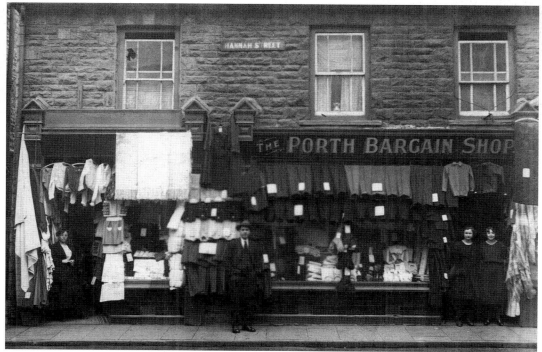

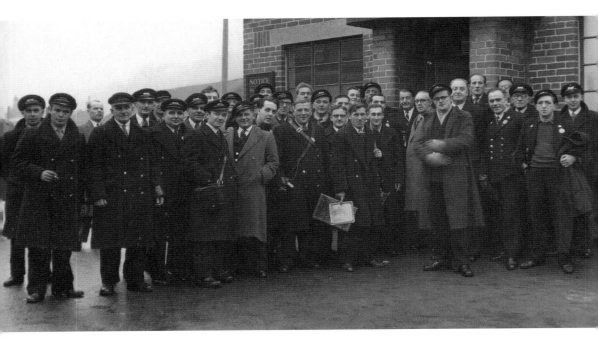

Rhondda transport workers outside the canteen at the bus depot, Porth, *c.* 1960.

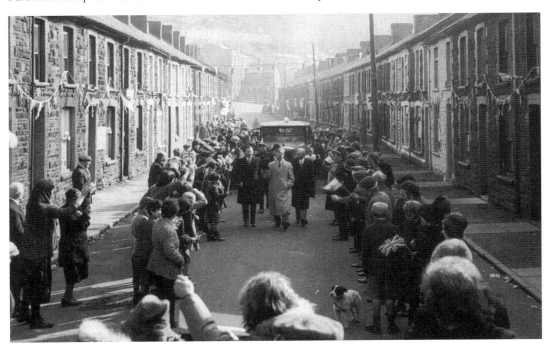

The Prince of Wales at North Road, Porth, during his visit to the distressed areas of the South Wales Coalfield in 1932.

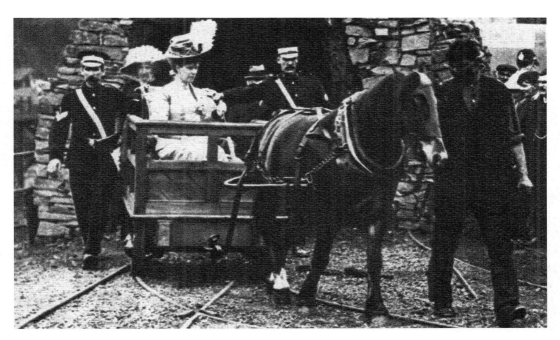

Leaving a model mine during a visit to the Lewis Merthyr Colliery by Queen Mary, 1912.

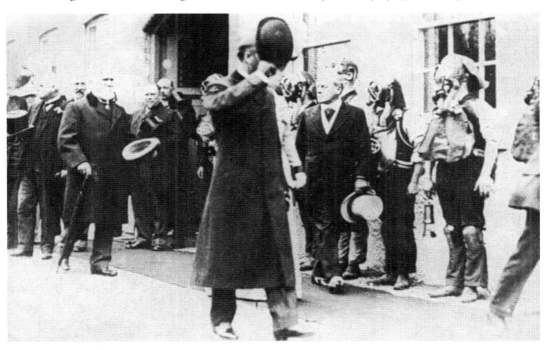

King George V officially opened the Miners' Rescue Station on 27 June 1912. The site is just 100 yards from the first shaft sunk in the Rhondda.

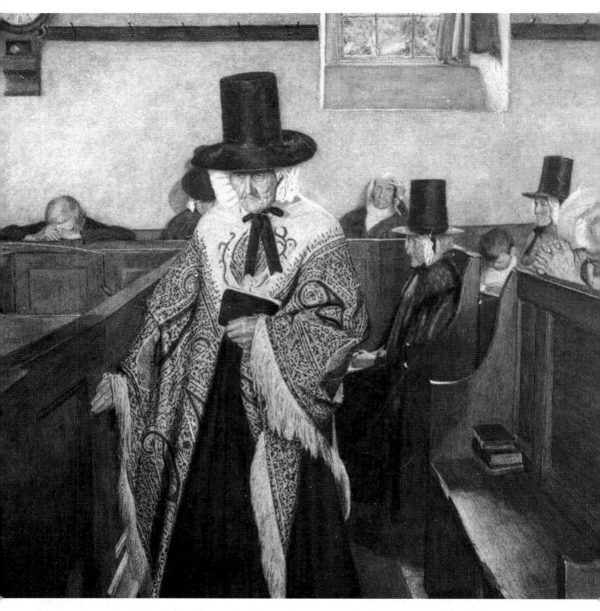

Mr Artro Evans of Birchgrove Street is Porth's connection with the painting, *Salem*. The lady in the portrait is Siân Owen, who had family living in Blanche Terrace, Porth. Mr Evans heard that the shawl in the portrait was cut in half, the Owens family retaining one half and the other half being taken away. Siân Owen and my mother, Mrs Bacchetta, came from the same district of Llanbedr and Gwynfryn and I remember other families in Porth who had come from that district: Mr and Mrs Ellis, in Woodfield, Mr Humphries the undertaker of North Road, and Mr and Mrs Pugh who settled in Ynyshir. The main reason for this influx of people from Llanbedr and Gwynfryn was ack of employment in the surrounding countryside and the call of the Rhondda Valley which was becoming a prosperous community because of the discovery of such large rich coal seams.

Salem Owed Its Shining Fame To A Bar Of Soap

Just as *Monarch of the Glen* is a visual burst of Scottish art and Constable's *The Haywain* has been absorbed into the English consciousness, so *Salem* has come to be something of an artistic icon in Wales. Yet it was actually painted by an Englishman, Sydney Curnow Vosper, who was born in Devon in 1866. The Welsh connection came through his wife, Constance (daughter of Merthyr solicitor Frank James), whom he married in 1902.

An incredibly popular artist, his work was frequently shown at the Victoria and Albert Museum, the Municipal Gallery in Merthyr and the Royal Academy, where *Salem* was first exhibited in 1909. But it was a much lowlier item which helped *Salem* achieve its huge popularity across Wales – Sunlight Soap. The painting was purchased by Lord Leverhulme in 1909 for 100 guineas; he then produced copies of it and offered them free to anyone purchasing 7lbs of Sunlight Soap at their local store.

In 1937, copies were distributed through the Urdd Gobaith Cymru (the Welsh League of Youth) and many more Welsh homes acquired it when it was reproduced as the cover of the Cymru Fydd calendar in 1950, '56 and '57. The painting has been the source of much fascination because of the hidden Devil: the strange outline of a face which can be distinguished in the folds of the old woman's shawl. Although the artist denied any intention of including Old Nick in his painting, the story merely added clout to the growing legend attached to *Salem*.

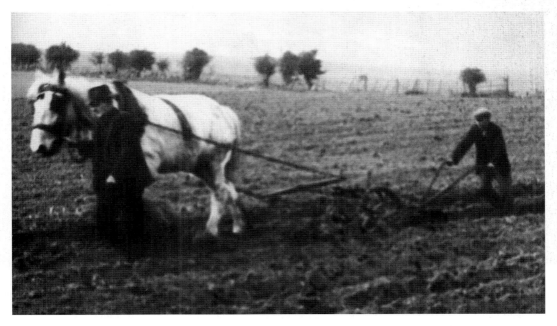

Mr Jones at Llwyncelyn Farm, leading his horse, Blossom, with Ken Smith ploughing the field, 1947. Mr Jones was the local milkman and supplied the traders in Porth. His cart was always full with large churns of milk, which were then left on the doorsteps of the grocery shops and cafes.

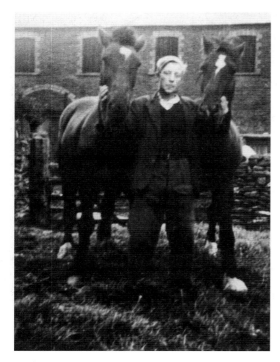

Ken Smith of Leslie Terrace, with Blackie and Peter on the farm, 1948. These horses were his pride and joy – as you can see, Ken kept them in tip-top condition.

Tynycymmer Hall, *c.* 1900, before alterations which took place when it became the South Wales Bible Institute.

The Pothecary family, well-known greengrocers of Hannah Street, who resided at Tynycymmer Hall during the 1950s.

Margaret Morgan was born on 15 June 1934. She lived at 35 Taff Street, Porth. She attended Ternacle Baptist Church in Hannah Street, Porth, from an very early age. After attending Ferndale Secondary School, Margaret went to train as a nurse at the Bristol Royal Infirmary. Whilst in Bristol she met Brenda Holton, who was a Sister in the Casualty Department and who was preparing to be a missionary in south-east Asia. Some time later, Margaret herself became convinced that she wanted to do this too, and so, after attending Mount Hermon Missionary Training College, Ealing, Margaret worked in South Thailand with the Overseas Missionary Fellowship. She worked in the Saiburi Christian Hospital, as both midwife and evangelist amongst the patients. In October 1971, Margaret returned from furlough to train at Monoram Christian Hospital for work amongst leprosy patients. Her work entailed travelling to village clinics, treating those suffering from the disease. It was while taking one of these clinics in Pujud that, in April 1974, she and fellow nurse Minka Hanskamp were taken captive by bandits. It was thought that they had been taken to nurse wounded bandits, and during their captivity news was heard from them on various occasions up until October 1974. In March 1975 their bodies were found in a jungle camp near Yala. Although the bodies were not found until this time, Margaret and Minka had in fact been shot by their captors five or six months previously.

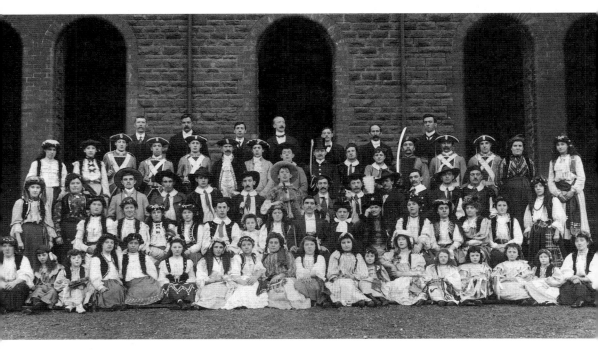

Llwyncelyn School, *c.* 1900. The cast of a grand *Gypsy Contata* showing off their theatrical costumes. These magnificent performances inspired the future stars of stage and screen that were to come from the mining background of the Rhondda Valleys.

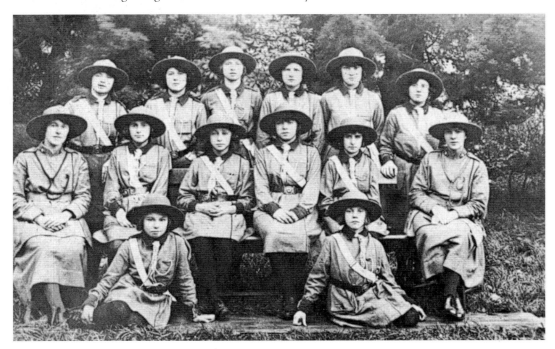

Pentre Citadel Salvation Army Life–Saving Guard.

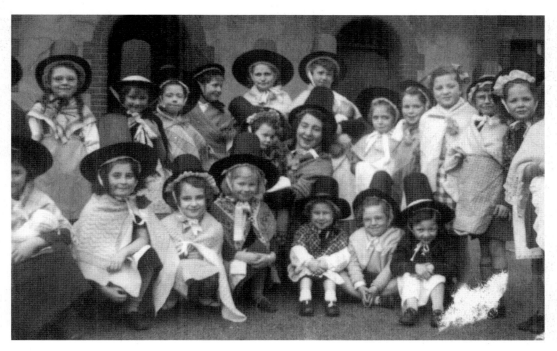

Islwyn Infants' School's St David's Day Celebration, 1952. The teacher was Miss Nell Thomas.

Porth Guides and Brownies at Gorwellion, Porthcawl, in the 1950s.

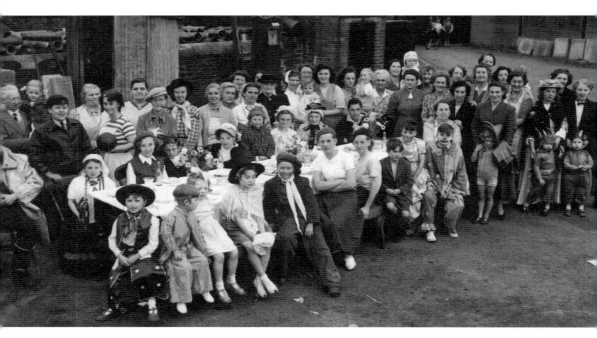

Residents of Aberrhondda Road, Porth, celebrating the Festival of Britain in 1951 at the Council Depot Yard.

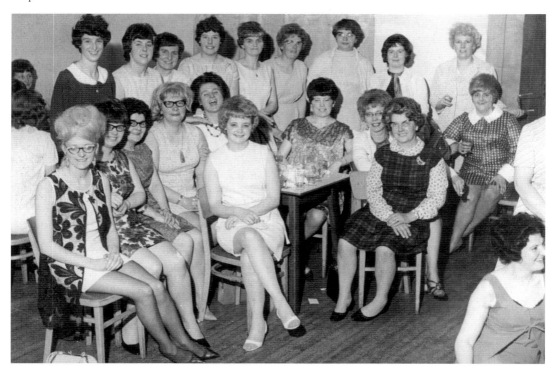

Ladies of the Ferndale 'Keep Fit' class, 1968 – WeightWatchers of the future!

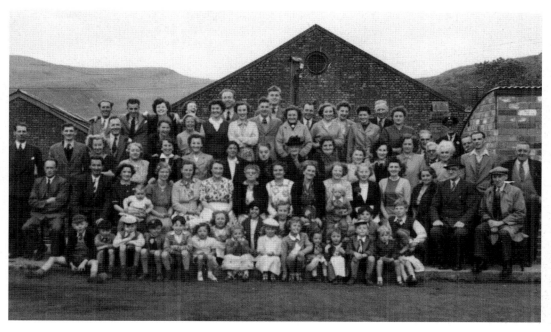

Residents of Aberrhondda Road, Porth, enjoying the Coronation celebrations in 1953.

The Ladies' Committee, Aberrhondda Road as seen here during the 1953 Coronation celebrations.

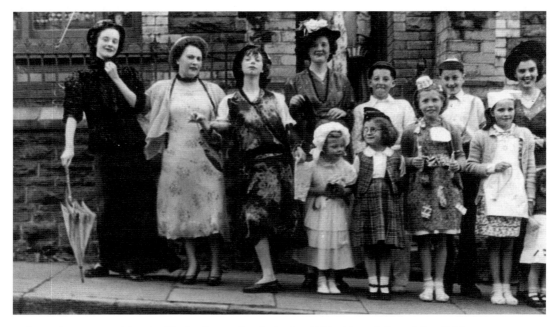

A fancy dress competition in Charles Street, Porth, in the 1950s. From left to right: Shirley Hopkins, Lyneth Blewett, Ann Blewett, Pat Hopkins, William Hopkins, Gwyn Griffiths, Joyce Davies, Diane Phillips, Pat Phillips, Tommy McNamara and daughter, Lilwell Harris.

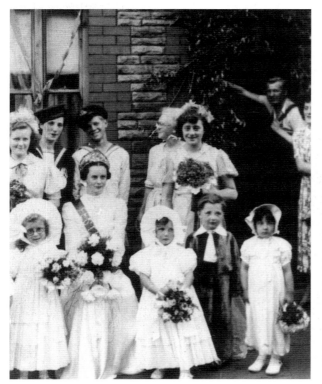

Left: The Porth Festival Queen, Charles Street, 1957. This photograph includes: Eileen Evans, Josie Rowlands, Donald Evans, Councillor Mrs Vaughn, Shirley Thomas, Norma Davies, Marie Thomas, Julie Rowlands, Bobby Rowlands, Christine Withers, Shirley Hopkins (Queen), Lilwell Harris.

Opposite below left: Cymmer Youth Club at Porthcawl, 1957. This picture includes: Mal Griffiths, Arthur Penny, Colin Ellis, Joyce Tuckwood, Gwilliam Davies, Nan Love, Ken Griffiths, Jean Jones, Brenda Beasant, Margaret Ellis, Danny Billington, Reg Boobyer, Glyn ?.

Opposite below right: Lilian Evans examining her machine stitching at Steinbergs clothes factory, Treforest, 1950.

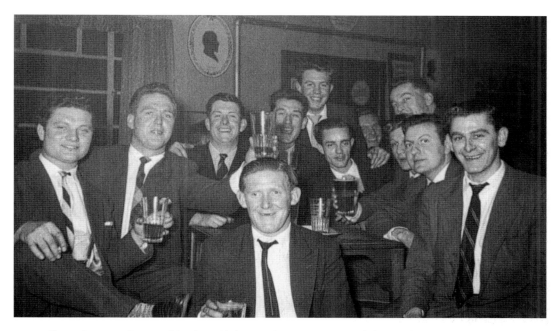

Above: Cymmer Boys White Star Club, St Athan, 1957. From left to right: Percy Griffiths, John Jones, Mal Griffiths, John Moses, Ciral Mortimer, Brian Jepson, Tony Gready, Fred Viner, Ken Thomas, Bill Rowe, John Davies, Brian Macey.

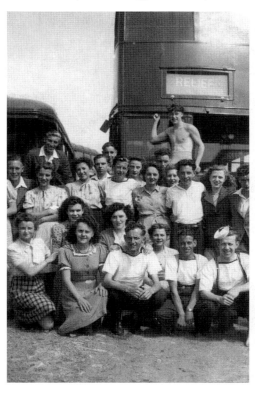

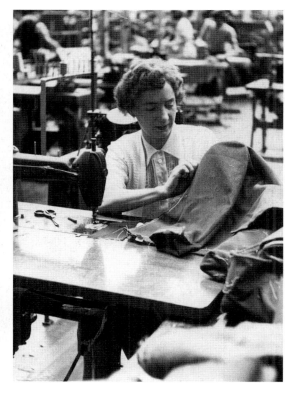

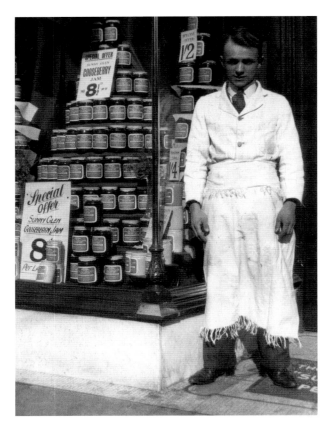

Left: Leonard Isaacs outside Thomas & Evans grocery shop, Hannah Street, Porth in the 1930s.

Below: Porth Rink, 1950s. From left to right: Cliff Harris, Arthur Pincott, Evan Davies, George Holman. The local hop was always a favourite attraction to meet the local talent!

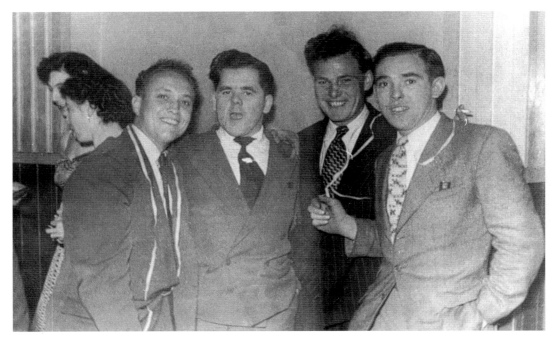

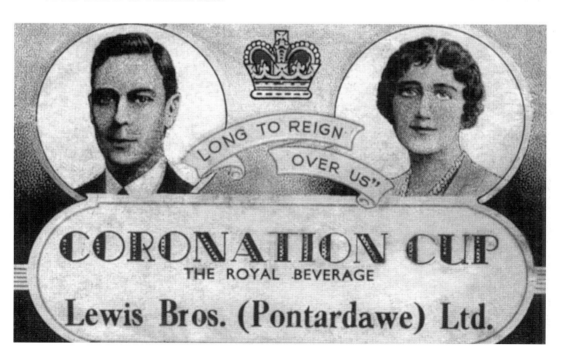

Right: A poster for a concert held at Cymmer Library, Porth in 1959.

Below: A label from a Sarsparilla bottle, 1953. This was a popular cordial drink in the Rhondda cafés.

CYMMER LIBRARY
7 P.M. THURSDAY, MAY 28th, 1959 7 P.M.

BILLIE	TREVOR
MURPHY	**MORGAN**

THE MERRY TOPPERS

ANN & BETTY	JACK CREWS

KEN HOWLETT	PAM AND LEN SAMUELS

3 TROTTOES	**3 ACES**

E. BLEWITT	**BILLY ROBERTS**

THE SINGING BIRDS

ADMISSION: 1/- & 2/-

O.A.P.

CELTIC PRESS LTD., PONTYPRIDD

"LONG TO REIGN OVER US"

CORONATION CUP
THE ROYAL BEVERAGE

Lewis Bros. (Pontardawe) Ltd.

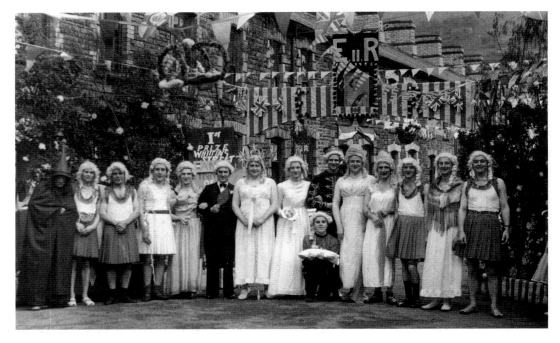

1953 Coronation fancy dress party in Whitting Street, Ynyshir.

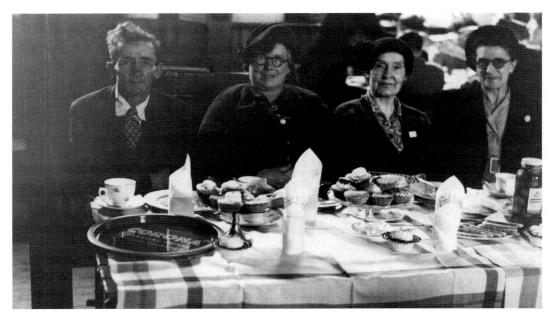

1953 Coronation party, Charles Street Methodist vestry. From left to right: Mog Scannel, Edith Scannel, Jemma Scannel, Dolly Martin.

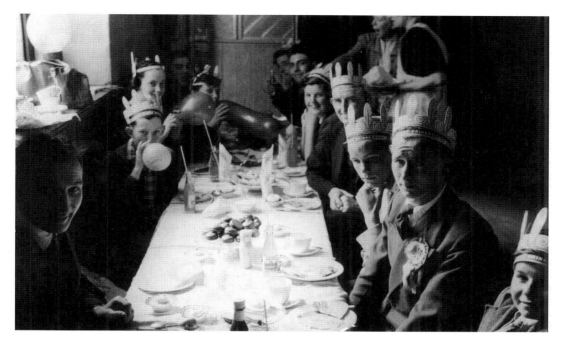

1953 Coronation party, Charles Street Methodist vestry. Clockwise: Tom Withers, William Hopkins, Shirley Hopkins, Ann Blewett, Joyce Davies, Gerald Richards, Brian Philips, Pat ?, Emlyn Hopkins, Phyllis Harris, Muriel Griffiths, Noel Evans, Donald Evans. Note the Corona hats.

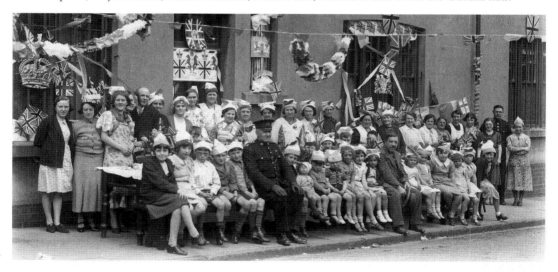

Coronation party 1937, Eleanor Street, Tonypandy. Included in this photograph are the police inspector for Tonypandy, Inspector Davies; Mr Will John (MP for the Rhondda); Mrs Williams, wife of the police sergeant; Mrs Will John, wife of the MP; Mrs Gill Thomas; Miss Lily Miles; Miss Mary Hughes; Miss Peggy John; Mrs T. Fred Evans; Miss Morgan, fishmongeress of Tonypandy. Some of the children are Roy Easton, Cyril Morgan, Billy and Kenneth Hoare, Frederick Williams (son of the police sergeant), Jean Mortlock, Sheila O'Keefe, Anne Mortlock, Doreen Cooke, Winnie O'Keefe, Mary Jones, Joan Evans.

Aberrhondda Road Coronation fancy dress competition, 1953. The photograph includes: Lynfa Morgan, Ann Hopkins and Janice Ford. Middle row: Susan Roberts, Mavis Hopkins and Janet Isaacs. Front row: Susan Jones, Colleen Lynch and Diane Adams.

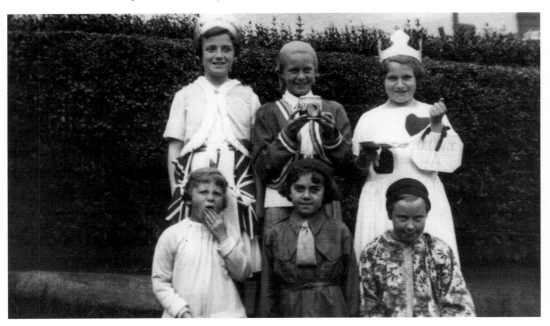

Coronation fancy dress winners in Aberrhondda Road, 1953. The winners are Ann Hopkins, Lynfa Morgan, Janice Ford, Mavis Hopkins, Susan Roberts, Janet Isaacs.

Stanley Baker: Ferndale to Hollywood

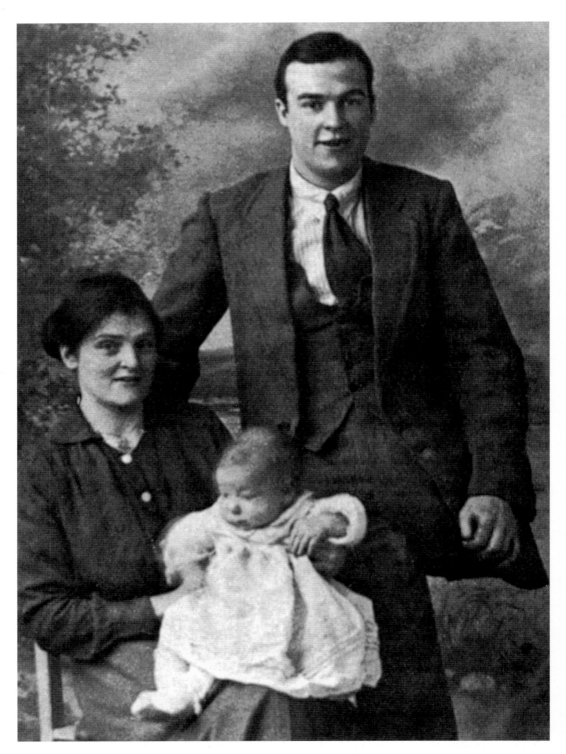

Stanley as a baby with his mother and father.

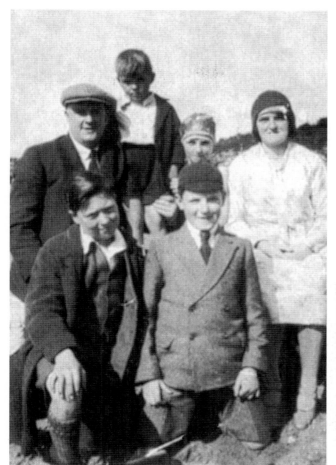

Left: The Baker family on holiday. Clockwise: Stanley's father, Stanley, his sister Muriel, his mother and in the foreground his brother Freddy and his uncle Cyril. Auntie Kate's wedding day. Kate is on the right and Auntie Annie on the left. The photograph was taken in the garden of the Baker house, Ferndale.

Bottom: Left to right: Stanley's aunt, his father and his mother.

Below: Stanley with his nephew John

A day's outing at Barry Island. From left to right: one of Stanley's aunts, his maternal grandmother, his mother, an uncle and his father.

A St David's Day celebration at Dyffryn Infants' School in 1936. Stanley is on the far left of the second row.

Stanley and his father, Barry Island, 1936.

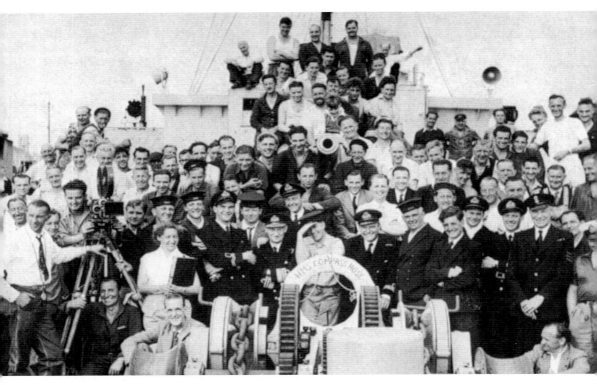

The cast of *The Cruel Sea* (1953), including Stanley Baker, Jack Hawkins, Donald Sinden, Glyn Houston, Sam Kydd, Denholm Elliot, Virginia McKenna, Moira Lister, Megs Jenkins.

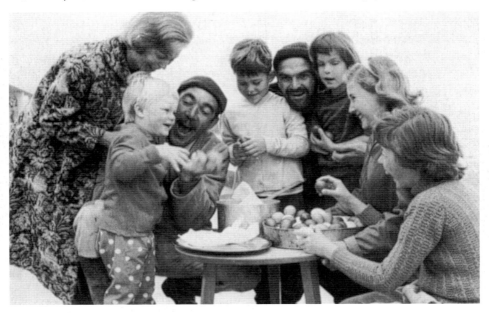

Easter 1961 in Rhodes while filming *The Guns of Navarone*. Reading left to right, the adults, Ellen ?, Anthony Quinn, Stanley and Jenny Quaile play with Glyn, Martin, Sally, and Rosanna.

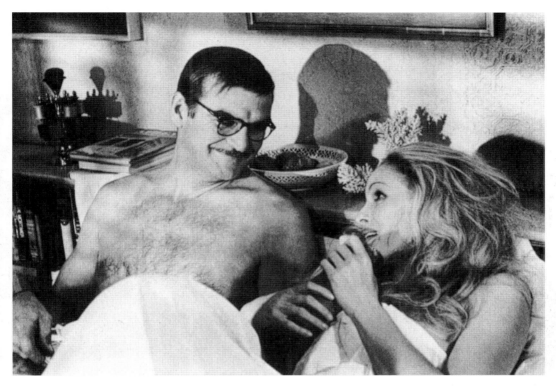

Stanley in bed with Ursula Andress while filming *Perfect Friday*.

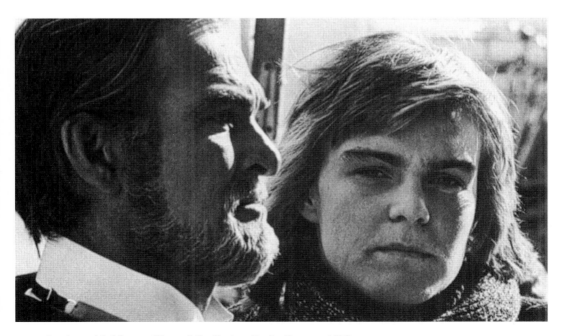

Stanley with his son Glyn while filming *Pepito Jimenez*, 1970.

Opposite: Stanley and his wife Ellen in April 1974.

Right: Stanley as Lt Chard in *Zulu,* 1964.

Rhondda's greatest screen actor Sir Stanley Baker will be the first movie star in Wales to have a plaque erected in his memory by the British Film Industry. The unveiling ceremony will be held on Friday 28 June in Greenwood Park, Ferndale – the twentieth anniversary of his early death at the age of forty-eight. A stone's throw from Baker's former home, the plaque will be unveiled by his widow, Lady Ellen, herself a former actress. On the same day, BBC Wales will screen the first major tribute to the actor.

The documentary, *Stanley Baker – A Life in Film,* charts his movie career over thirty-three years, from the age of fourteen, when he was plucked from school to appear in the Ealing Studios 1943 drama *Undercover,* to his swansong as the family patriarch Gwilym Morgan in the BBC's 1976 version of *How Green Was My Valley.* Baker died of cancer six weeks after receiving his knighthood. Film historian Peter Stead describes *How Green Was My Valley* as the 'great Welsh Western', and Zulu was Baker's greatest screen triumph, as star and co-producer. The film was his brainwave, was nurtured by him and scored a spectacular box office success, grossing $12m worldwide by 1976 – at least eight times its cost.

In the documentary, the African Chief, Buthelezi describes the film as respectful to the bravery and memory of men on both sides and recalls Baker as a loveable man. All his life Baker remembered Ferndale and often returned there. 'He among all the Welsh actors never lost his Welsh identity', said Siân Phillips.

Stanley, Siân Phillips and the cast of *How Green Was My Valley*, 1975. This was to be his last screen appearance.

Stanley Baker died of lung cancer in 1976, aged just forty-eight. He will be forever remembered for his starring role in the film *Zulu* (made for around $1.5m), which he also produced. By 1976 the film had grossed $12m and has since been screened worldwide. Baker was born for the screen: he seemed to carry into his roles the toughness, restlessness and defiance developed in his harsh early years as a miner's son in his beloved Rhondda Valley.

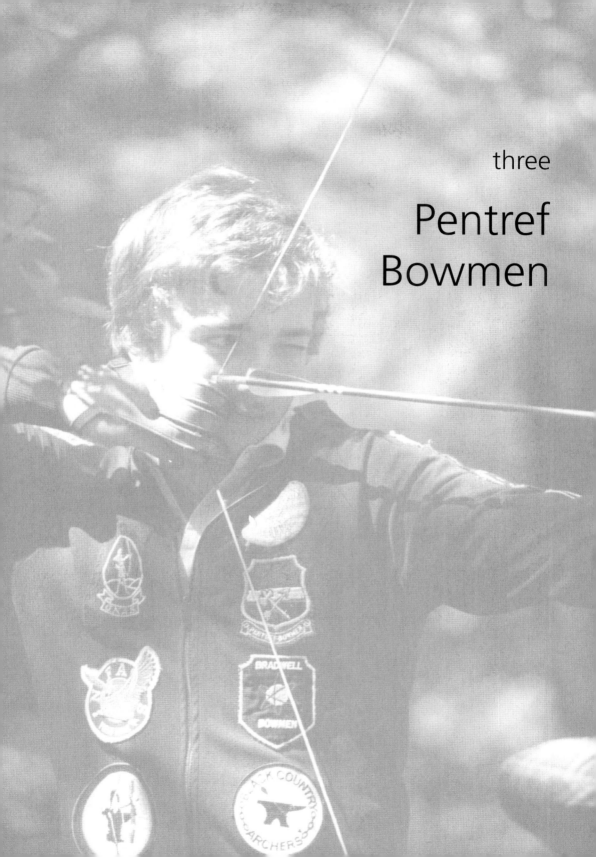

three

Pentref
Bowmen

Pentref Bowmen

Glyncornel Archery Centre, Llwynypia, Rhondda. Tel: 01443 432490

Web site: www.pentref-bowmen.com

Pentref Bowmen are based at the archery club house, Glyncornel.

The History of Pentref Bowmen

On 22 August 1952, eight people met informally in the Welfare Rooms of the Ton Co-op Society to discuss the idea of forming an archery club. At this meeting they officially formed the Pentref Bowmen Archery Club and decided that membership should be made open to any members of the public. Future meetings were held in a room at a local public house when the membership gradually grew. The first practice was held on 4 September 1952 on a field near Tonypandy Square, which was owned by one of the members. It is interesting to note that the Welfare Rooms, the local public house and the first practice field no longer exist.

Shooting practice continued on various sports fields in the locality until May 1953, when the club took over the use of an old tennis club in Ton Pentre. This provided the members with more space in which to practise and a small club house. To achieve the longer distances involved, members used to shoot from the side of an adjacent coal tip, across a mountain track, and on to the club ground. Much hard work was involved in bringing the club house up to a reasonable standard, and the battle against vandals began which continues to the present day.

Over the next few years, the club was devoted entirely to target archery, forming a team to visit the local pubs and clubs and give demonstrations, as well as competing in archery darts. In September 1956, some of the members took an interest in field archery and the club divided into two sections. Gradually, over the next few years, the club became solely devoted to field archery and became affiliated to the British Field Archery Association.

The first major field tournament was on the mountainside above Ton Pentre. This entailed a half-mile walk from the clubhouse to the course. This tournament, and subsequent ones, were so successful that some years later the club organised the BFAA National Championships at Coedely Woods near Llantrisant. This event attracted the largest entry for a field archery tournament up to that date, and was notable for the fact that a field course was laid which enabled wheelchair archers to take part – the first, and probably only, time this happened.

Present Site Acquired

In 1967 the club acquired the lease of 55 acres of Nantgwyddon Woods, and the Glyncornel Archery Centre was born. Much hard work from the members was needed to convert the old vegetable gardens into the headquarters of the club, and to convert the old buildings into a clubhouse, as well as constructing the courses for the members to shoot over. In 1968 the First All-British and Open Field Archery Championships were organised by the club on behalf of the Grand National Archery Society and these have been held on the last weekend in May ever since.

The crowning achievement came in 1970 when due to the late withdrawal of the appointed country, the GNAS was persuaded by the club to stage the second World and first European Field Championships here in Rhondda. During the preparation for this tournament, the club went through its greatest development period when, with grant aid from various bodies, the car park and roadways, the main hall and log cabin were built. Even though the weather was atrocious for the weeks before and during the first day of the event, the Championships were very successful, with eleven countries competing.

In 1969 the club's association with the Lindome Club of Sweden began. The Lindome Club regularly sent a team for the All-British for many years. Archers and teams from all over the world have visited Glyncornel over the years, including Italy, Switzerland, Holland, France, America and Japan. A number of club members have also carried the name of Pentref Bowmen to other countries, both as archers representing Great Britain and also as officials in major championships. In recent years the club, as a group, has visited other countries, spreading the word to Luxembourg, Belgium and Germany. We hope that this will continue in future years.

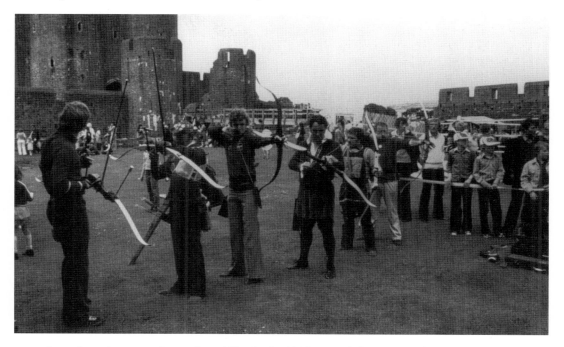

An archery demonstration at Caerphilly Castle, 1982. From left to right: Glynn Rudd, Gary Davies, Brian Davies, all Pentref Bowmen.

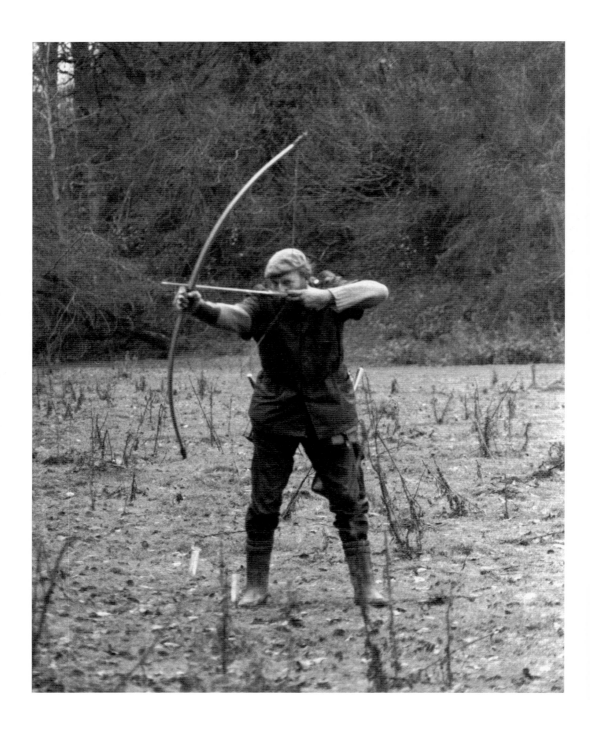

Peter Benbow from Liverpool, a regular competitor at Pentref Bowmen's Archery Club, seen here competing in the 1985 British Championship with a traditional longbow.

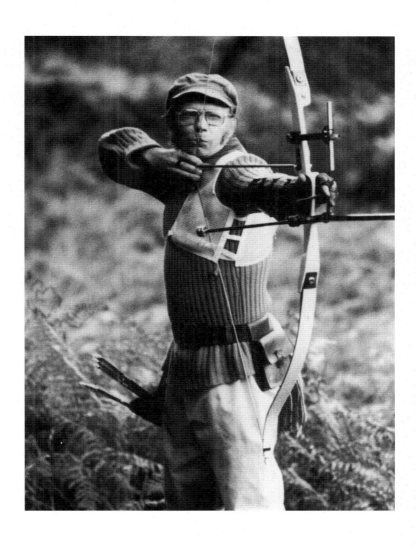

Glyn Rudd competing at the Welsh Open Championships, Pentref Bowmen Archery Club, 1985.

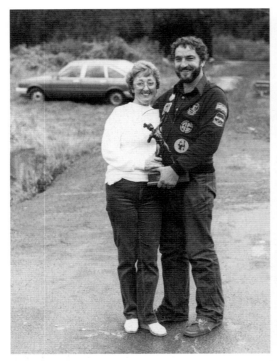

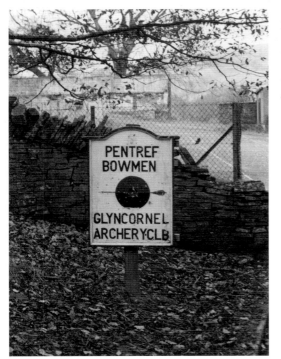

Above left: Brian Davies, winner of the Welsh Championship in 1980, with his wife Anthea.

Above right: Gary Davies, Pentref Bowmen Junior Champion and British record holder, 1980.

Left: Entrance to the Pentref Bowmen club in Llwynypia

The year of the castles. Members of Pentref Bowmen in fancy dress at Llantwit Major, 1984. From left to right: Emma Rudd, Margaret Rudd, Ken Phillips.

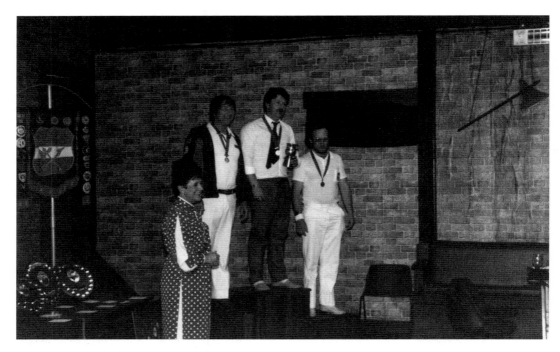

Pentref Bowmen arriving for the Eight Nations Championships in Luxembourg, 1983.

Opposite above: Presentation of trophies at the British and Open Archery Championships, Pentref, 1986. First place, Phil Bowen; second place, Roy Mundon; third place, Colin Hobbs. The trophies are presented by Hywis James.

Opposite below: Members of Pentref Bowmen receiving an award at the Luxembourg National Championships, 1983.

Three jolly Belgian archers toasting good health and good shooting at the Luxembourg National Championships, 1983.

'Bunny Target', one of the named targets at the Luxembourg Championships, 1983.

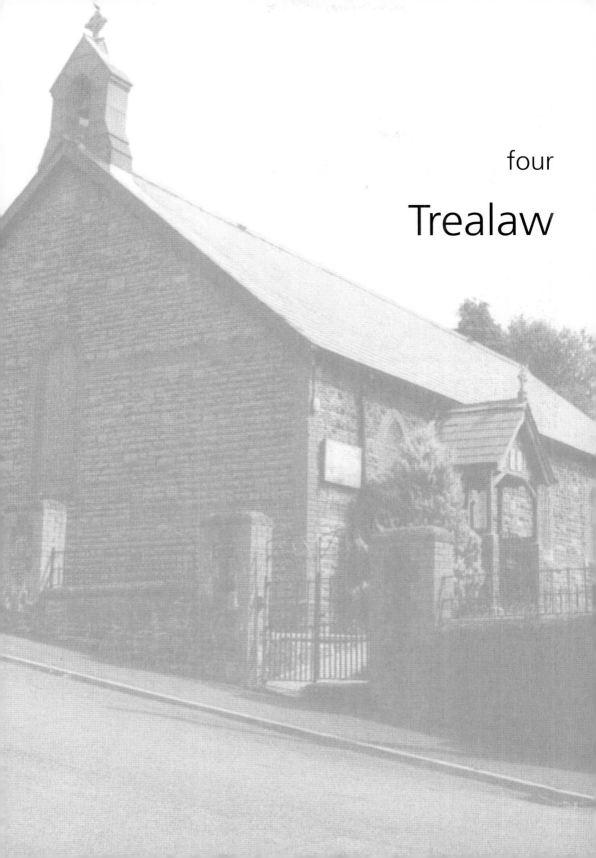

four

Trealaw

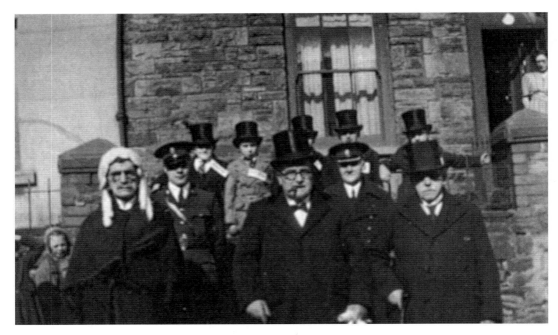

From left to right, back row: members of Churchill's Cabinet. Front row: Lord Chief Justice, Winston Churchill, Lloyd George. All were locals taking part in a fancy dress parade to raise money for the war effort, Rhys Street, Trealaw, 1941.

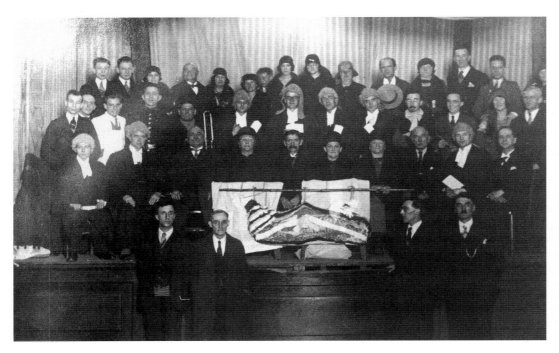

Trealaw flitch trial, Judges Hall, 1929. A fair and impartial trial by Jury, who consisted of six eligible bachelors and six modest maidens.

TUESDAY, MARCH 17th. -- 1931

"PORTH" FLITCH TRIAL.

A fair and impartial trial by Jury, who will consist of six eligible Bachelors and six modest Maidens.

A whole Flitch of Bacon (kindly given by Mr. GLANMOR HUGHES, Grocer), will be presented to the couple who receive the Jury's verdict.

If you have been married a year and a day, and not had a cross word or quarrel, the Bacon is yours.

Officers.

Judge	-	Mr. FRANK HILL (Talygarn)
Clerk of the Court	-	Mr. B. PROTHEROE (Barclays)
Counsel for Flitch	-	Mr. W. G. JAMES (Talygarn)

Counsel for Applicants---

Mrs. B. WATTS MORGAN. Councillor JACK MORGANS.
Councillor W. D. THOMAS (Solicitor). Councillor S. P. WILSON.
Mr. T. D. LAWRENCE, O.B.E.

Application to Secretary, c/o CASH & CO., Hannah St., Porth.

ADMISSION - Reserved Seats, 2/-, 1/2 and 6d. (Including Tax).

Porth flitch trial.

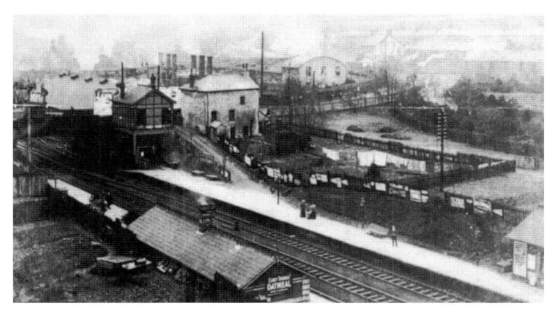

Llwynypia station (Taff Railway), *c.* 1895.

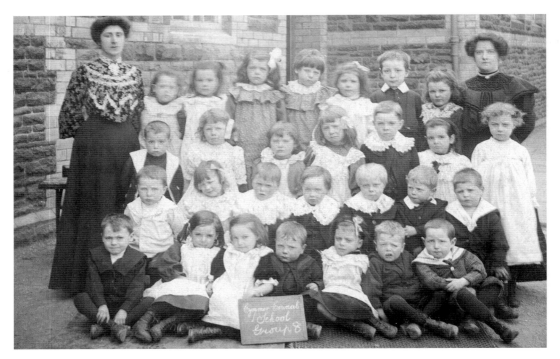

Trealaw Mission, *c.* 1900.

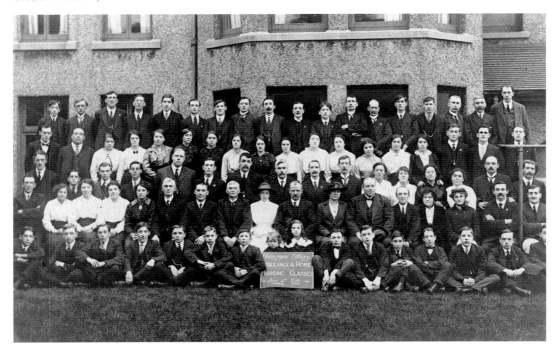

Glamorgan Colliery ambulance and home nursing classes, 1910.

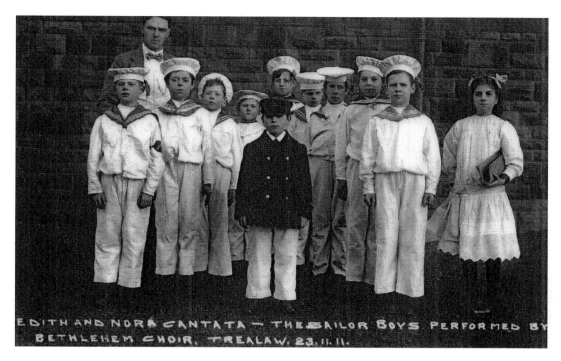

EDITH AND NORA CANTATA — THE SAILOR BOYS PERFORMED BY BETHLEHEM CHOIR, TREALAW. 23.11.11.

Bethlehem Welsh Baptist choir, Miskin Road, Trealaw, 1911.

James Cagney and his gang with Great Uncle Sam Thompson, middle of back row, Trealaw, 1940s.

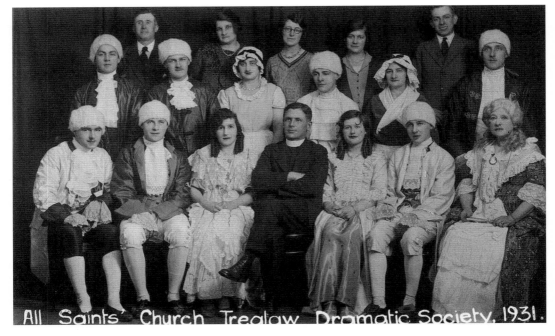

All Saints Church, Trealaw dramatic society, 1931. Included are Annie Jones, Lil Bailey and Mrs Griffiths

A Short History of All Saints Church, Trealaw

On 1 November 1897, All Saints Church, was opened and dedicated by the Right Revd Richard Lewis, who was at that time the Lord Bishop of the Diocese of Llandaff. All Saints Church was built as a mission church in the parish of St Andrew's, Llwynypia, during the incumbency of the Revd John Daniel James, who later became Archdeacon of Llandaff. The building is of native stone and, according to records, cost (inclusive of furnishings) £1,050. A newspaper's report of the opening services states that the special preachers, in addition to the Bishop of the Diocese, were Canon Johnson (Warden of St Michael's College, Llandaff) and the Revd H.J. Williams (Rector of Dinas Powis). In 1920 Trealaw was made a Conventional District, and in 1924 it was made into an Ecclesiastical Parish, with the Revd Charles Renowden as the first vicar. Soon after this, the present vicarage house was bought and a church hall built, the latter being opened on 1 January 1925.

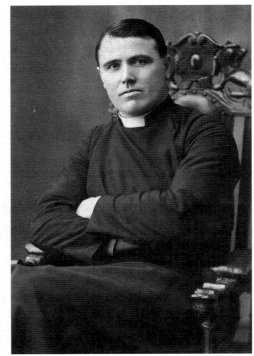

Revd Charles Renowden. This photograph was taken between 1924 and 1926.

Trealaw Church.

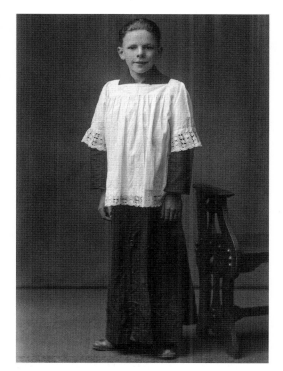

Altar boy Martin Phelan, St Gabriel and
Raphael RC Church, Tonypandy, 1924.

Eileen Phelan in the May Procession, St Gabriel
and Raphael RC Church, Tonypandy.

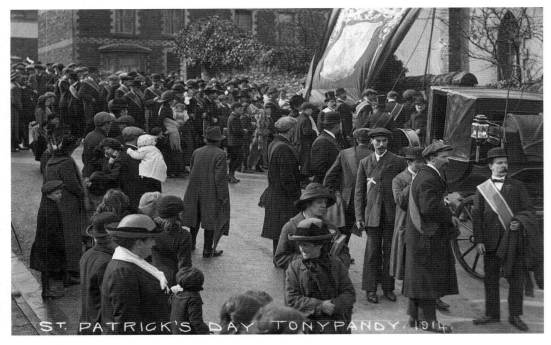

St Gabriel and Raphael RC Church, Tonypandy, St Patrick's Day 1914.

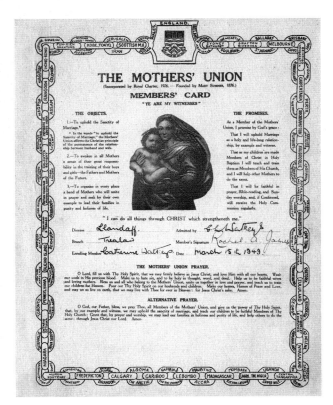

A Mother's Union certificate, issued by All Saints Church, Trealaw, 1949.

five

Hetty

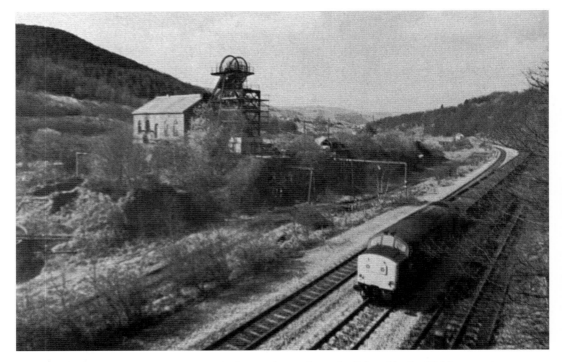

Hetty engine house and winding gear. The last coal train from the Rhondda Coalfields passes by in 1983.

The Hetty Winding Engine, Ed Cloutman

The Hetty Winding Engine is undergoing restoration under the direction of Brian Davies, curator of the Pontypridd Museum. One cannot mention the Rhondda without coal: the two are synonymous; an insight into the South Wales coal-mining industry is included in and forms an introduction to the Hetty Engine display. The local mining industry is well portrayed in the Pontypridd Museum. A small private museum is also mentioned in this chapter as it forms an important part of the Welsh Valley's social history.

An engraving by Henry Gastineau from around depicts the Rhondda Valley with wooded hillsides and meadows stretching down to the river, which meanders its way to the sea at Cardiff, making it appear a very rural and peaceful place. In fact, the bridge in the picture is very close to the river crossing by the Hetty engine house. In 1908 Arthur Morris wrote 'The River Rhondda is a dark, turgid and contaminated gutter, into which is poured the refuse of the host of collieries which skirt the thirteen miles of its course. The hills have been stripped of their woodland beauty, and there they stand, rugged and bare, with immense rubbish heaps covering their surface.' He goes on to say that the peace of the valley is broken by the din of steam engines, the whirr of machinery, the grating of coal screens and the hammering of smithies, both day and night. Within one generation, the population of the Rhondda increased from around 2,000 to over 150,000. Mining developed in all of the major valleys with names such as the Gwendraeth, the Amman, the Towe, the Nedd, the Dulais, the Afan, the Llynfi, the Garw, the Ely, the Cynon, the Taff, the Rhymni, the Sirhowy, the Ebbw, the Llwyd and, of course, the Rhondda.

The South Wales coalfield is composed of three main coal types: anthracite in the deepest levels; steam coal in the deep and middle ranges of the coalfield; and bituminous coal close to the surface. Anthracite has a high carbon content and is not suitable for open grates or steam boilers, but is good for central-heating furnaces and stoves for heating glasshouses and hothouses. The best steam coals burn with little smoke or clinker and give a bright, hot fire. Thus they are most suitable for the boilers of ships and locomotives. Bituminous coals produce smoke and gas, and are most suitable for use in open grates, the manufacture of gas, and for smelting metals.

The coalfield developed in stages as requirements changed; until the seventeenth century, mining was concentrated along the fringes of the coalfield, where the coal lay near the surface and could be mined by opencast or in drift mines, tunnels running into hillsides, following the coal seams more or less horizontally. This was made more cost effective by the close proximity of carboniferous limestone lining the basin in which the coal measures lie, and thus outcrops at its margins. Hence, many lime works were concentrated in these areas. Most of the coal produced at this time was used in open fires and by some industries.

During the seventeenth and eighteenth centuries, more coal was required. It was more economical to send ore from mines in North Wales and Cornwall to South Wales, than transport the coal to the copper mining areas. Neath and Swansea became the largest copper-smelting areas in Britain, and Swansea the largest town in Wales.

By the nineteenth century, coal was being used for the smelting of iron, and Merthyr Tydfil became the largest town in Wales, with large ironworks at Blaenavon and Dowlais. The output of the ironworks was largely pig iron, most of which had to be carried down the Taff Valley to the port of Cardiff on horseback or on carts. This was a distance of some 25 miles, and the difficulty of transporting the iron greatly restricted the expansion of the industry, leading to the development of the Glamorgan Canal. Barges could now handle up to 25 tons of iron, rather than hundred-weights.

The canal became very successful, and by 1799 congestion and the shortage of water in the upper reaches led to a bill being presented to Parliament for the construction of a tram road. After considerable opposition, construction of the Merthyr tram road began in 1800, between Merthyr and Abercynon. Ownership was divided between the Dowlais, Penydarren and Plymouth ironworks. The iron rails were set on large stone blocks with a gauge of 4ft 4ins, the remains of which are visible today . Each rail was a yard long and weighed 56lbs, and was held in place by a long spike. One horse was used to pull five full wagons downhill to Abercynon, carrying ten tons of iron. The same horse would then pull the empties back to Merthyr. Part of the original tramway is now a portion of the Taff Trail, which is a cycle way from Brecon to Cardiff.

In 1803, Richard Trevithick was brought to the Penydarren ironworks to install high-pressure stationary engines, which were considered more efficient than the existing machinery. It was not long before it was decided to try one of his road locomotives on the tramway, prompting the development of the Penydarren locomotive. The hauling capacity of the engine was proved beyond question, but the experiment was short-lived because the weight of the locomotive caused the rails to fracture. Rather than scrapping the locomotive, it is probable that it was used as a stationary engine at the Penydarren Works.

The final stage in the development of the coal industry was the production of 'sale-coal'. This was coal that was produced primarily for export, but was also used in increasing numbers of coal fires in homes in Britain, as well as by other industries. The

Melling's patent expansion valve gear.

Three eccentrics to drive Melling's valve gear.

Whitmore over-wind and over-speed gear.

A 16ft-diameter drum converted to take round steel rope rather than flat rope.

export trade led to the expansion of ports in Newport, Llanelli, Barry and, of course, Cardiff and Swansea.

At first mining was carried out in bell-pits, which, as the name implies, were bell-shaped holes dug in the ground and joined to the surface by a short vertical shaft. From these, horizontal galleries were handcut into the coal seams and the coal winched to the surface by hand. A similar method was used in the Neolithic flint mines at Grimes Graves in Norfolk. If the pit flooded or collapsed, it was easier to dig another adjacent pit rather than pump the water out or shore up the sides with timber. Also, the pits did not have to be artificially ventilated.

By contrast, to reach the steam coal and anthracite at all but the edges of the South Wales coalfield required the sinking of deep shafts. Headings were driven from the vertical shaft and the coal seams worked from these. The excavated coal, and miners, would return along separate roadways. Other areas were cleared for the storage of machinery and trams, and to provide stables for the pit ponies.

These mines were expensive to operate as they required wooden props to shore up the roofs, as well as pumps and fans to remove water and ventilate the mines. There was the constant fear of explosion from coal dust and methane gas 'fire-damp'. Suffocation was also a danger caused by carbon dioxide poisoning – 'choke-damp'. Ever present was the threat of collapse and flooding, and the only light before electricity was by candle or oil lamp. Children as young as six, both boys and girls, were used to stand by the doors and open and shut them as required. These doors were required to ensure that the ventilation worked correctly as they operated like valves, the fans taking in air from one vertical shaft and expelling it to the atmosphere via another. The children would work twelve-hour shifts, often standing in total darkness, in constant danger of being run over by a tram or trampled on by a pony.

A mining experience can be undergone by a trip to the Big Pit Museum in Blaenavon, where you are kitted out with the correct miner's gear: lamp, lead battery pack and helmet. It is a real mine and therefore all the relevant safety precautions are taken. You are taken through the galleries and shown the stable area and machinery – all that is missing is the dirt and noise. Everything is very peaceful and it is an experience that should not be missed.

To bring the coal to the surface and transport the miners, some form of winding machine was required. In the early days this would have been man-powered, and later horses were used. A water-balance method was also employed, which consisted of a water bucket attached to each end of a rope. The empty trams were placed on the top of the upper bucket and the full ones on the lower one. Water was added to the upper bucket until it was heavy enough to lift the full tram, and on reaching the bottom of the shaft, the water was immediately drained off.

As production increased and shafts were driven deeper, more efficient methods were required, and with the introduction of steam power, winding engines were the obvious successor. These were later superseded by electric power. Further engines were required to drive the ventilation fans and pumps.

The uses that the steam coal was put to was often reflected in the names of the coal companies, such as 'Navigation', 'Naval' and 'Ocean'. These names appeared on the sides of the coal trucks that trundled up and down the valleys delivering their cargo to the ports of Cardiff, Newport, etc. Companies often advertised by boasting that they supplied the Admiralty or ships of the Cunard line, such as the *Mauretania* and *Lusitania*, or the Royal yachts and the railways.

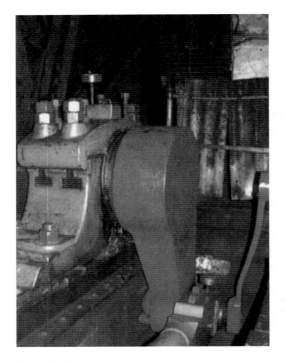

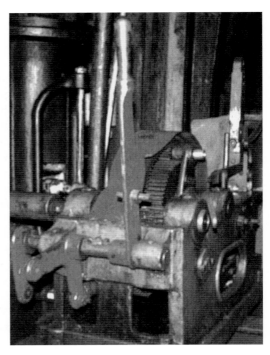

Slow banker.

Modified crank to drive valve gear.

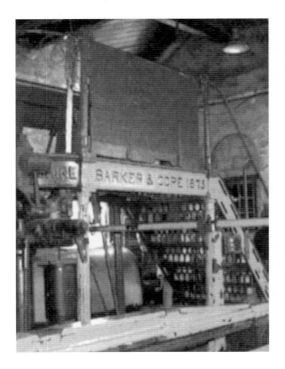

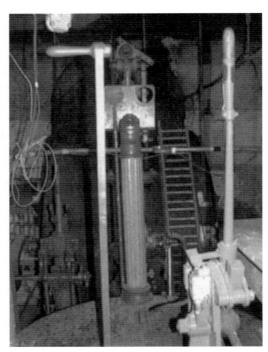

A driving platform with cast-maker's name visible.

Regulator and brake controls.

The Hetty Engine

The Hetty Winding Engine lies in the Rhondda Valley and began life as part of the Great Western Colliery Company. In 1844 John Calvert obtained the rights to mine coal at Newbridge Colliery, which was sunk to the No.3 Rhondda seam at a depth of 50 yards – the colliery continued producing coal until 1897. Meanwhile, he sank another shaft to the No.3 Rhondda seam at Gyfeillion at a depth of 149 yards, which took three years to complete. The colliery was purchased by the Great Western Railway Company in 1854, worked profitably for ten years and was then sold back to Calvert.

The Great Western Colliery Company Limited was formed in 1866 and sank two more shafts to mine the deeper steam coals, one of which was the Hetty. This shaft was 16ft in diameter and was sunk to a depth of 392 yards. The original winding engine was built by Barker and Cope of Kidsgrove, Staffordshire, and was installed in 1875. It had two 40in-bore by 6ft-stroke low pressure cylinders, coupled to a 16ft-diameter drum using a flat winding rope. It ran for twenty-five years in this condition and raised some 6 million tons of coal. In 1880 there was a spectacular over-wind, which sent a sheave spinning over the roof of the engine house and proceeded to demolish a house on the riverbank opposite. Fortunately, no one was hurt. However, by 1900 the Hetty engine was obsolete because the Great Western colliery increased its output and was briefly the largest colliery in South Wales. The rapidly increasing coal output and the depth of the Hetty pit required a more efficient engine.

Modernising the Hetty engine posed a problem in that it had to be accomplished whilst the pit was providing coal, with as little disruption as possible. Due to the proximity of the railway and the road, it was not possible to construct a new winding house either behind or on the other side of the existing pithead. Somehow, the old engine had to be modified *in situ*. Thus, it was decided to fit new high-pressure cylinders (34in diameter by 6ft stroke) and piston valves by Worsley Mesnes of Wigan. Melling's patent expansion valve gear was also fitted, which required three eccentrics. New steel sections by Dorman Long of Middlesbrough were required for the 16ft-diameter drum, which was converted to take round steel rope to replace the flat wire rope.

This change to round rope posed two problems: to retain the length of rope, either the drum would have to be increased in diameter or it would have to be made wider. Available space restricted both of these modifications, so instead Hugh Bramwell, the colliery's chief engineer, designed a drum that would allow the rope to wind back on itself. Bramwell, incidentally, was responsible for the Hetty modernisation programme. A new steam brake by King of Nailsworth, Gloucestershire, was also installed, and Whitmore patented over-wind and over-speed gear made by Fraser and Chalmers of Erith, Kent. A 'slow-banker' was also installed. This was coupled to the over-wind and over-speed gear, so that the latter could operate at the slower winding speeds required when winding men up and down the shaft. The modifications required the valve gear and eccentrics to be moved outboard of the main cranks, hence the need for the separate cranks to drive them.

The Hetty engine continued in this modified form for a further twenty-one years, raising some 5 million tons of coal, but its life as a coal winder ended in 1926, when movement of the geological strata caused a 'kink' in the Hetty and the adjacent No.2 shaft. A new shaft had to be sunk about a quarter of a mile away, and the new workings became the Ty Mawr colliery after the re-organisation of the Great Western. The new workings were linked to the old, and the Hetty shaft became an emergency shaft. The

new Ty Mawr pit was completely electrified, thus it was not economical to keep the large boilers in steam solely for the Hetty engine, nor was it worth replacing the engine with electric winders. So, the Hetty engine was converted to run on compressed air, which required no mechanical alterations, only the use of thinner oil.

The Hetty engine continued for the next sixty years until the closure of the Ty Mawr colliery in 1983. It was run a few times each day and regularly maintained. Its bright metal parts began to rust after the conversion from steam to compressed air, so they were painted in the Great Western locomotive colours of green and red.

One of the most interesting features of this engine is that when modifications took place, the original gear was disconnected and left in place. Thus, a more or less complete record of the engine's history is present. For example, three governors remain – each from a different era – and the remains of the 1928 electric bell signalling system and the previous mechanical hammer-and-plate signals are present. Linked to the Whitmore over-wind and over-speed gear is a 'Lilley' controller, which is coupled to the steam brake via a solenoid. This upgrade was carried out in the 1950s. In front of the engine house was the fan ducting which ventilated the workings. The Hetty shaft acted as an up-cast ventilator, using a 'sirocco' fan to draw air up the shaft and out of the workings.

On the way up to the engine house, you pass the old capstan engine. This twin-cylinder steam engine was used to raise and lower cages or equipment during maintenance of the shaft. This type of engine was also used during shaft construction, but this particular example is thought to be of about 1900 vintage. Once inside the engine house, you can see the more recent panel of interlocking safety switches and indicator lights and the driving platform with the maker's name clearly visible, cast into the frame. The beautiful cast steps leading to the platform can be seen and the two main controls. The lever on the right is the brake and on the left is the regulator, which is coupled to the main steam valve, located immediately beneath the platform. Another feature of interest is that parts of the engine had to be crack-tested, and this can be identified by the white paint seen on some of the parts, such as the bracket which holds the cage indicator mechanism.

The engine is well worth a visit, especially as Brian's team are a friendly bunch! On certain days, the engine is run on compressed air, and hopefully, in the future, a boiler will be installed, allowing steam operation. For more information on the Hetty Engine House, contact Brian Davies at the Pontypridd Museum.

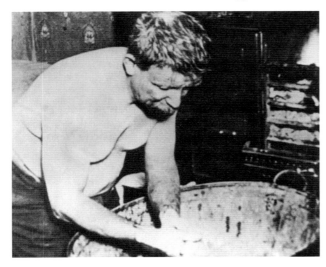

Bath-time in the Rhondda, *c*. 1900. There were no pithead baths, just a tin bath in front of the kitchen fire.

The Price of Coal

In our little valley
There were so many mines
They stood there as a monument
Long before my time

My father was a miner
Toiling in that deep sod
Working from dusk till dawn
Then wearily home he trod

My mother there to greet him
With a kettle on the boil
To give him some refreshments
After his daily toil

The bath was filled by the fire
The coal dust washed away
But you cannot wash it from your lungs
The doctor says it's there to stay

The men came from England
They closed our collieries down
Building factories and museums
And expanding all our towns

The museums tell the story
Portraying all our ways
But they do not tell of the suffering
And of the poor pays

The wheels have stopped turning now
The hooter never again to call
The men have gone back to England
They think they know it all

But they do not know what's in our hearts
Or the feelings we have inside
Or of the men who risked their lives
Just to keep them satisfied

Yes, the collieries are all closed now
Our men are on the dole
Unlike their fathers before them
That paid for the price of coal

Mrs Green, Ynyshir

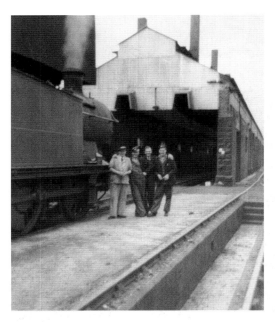

Ferndale railway shed just before it closed in the late 1960s. From left to right: train drivers Alfie Dudson, Tom Williams, Graham Poulton, Norman King.

Gary Kingsbury, fireman at Ferndale railway shed, 1958.

Above: Two British Rail engines getting ready to haul coal down the valley to Cardiff Docks, 1956.

Opposite: An artist's impression of the Penygriag Colliery disaster, drawn for the *London Illustrated News*. The disaster, which occurred on 27 August 1909, injured eighteen people and killed a further six.

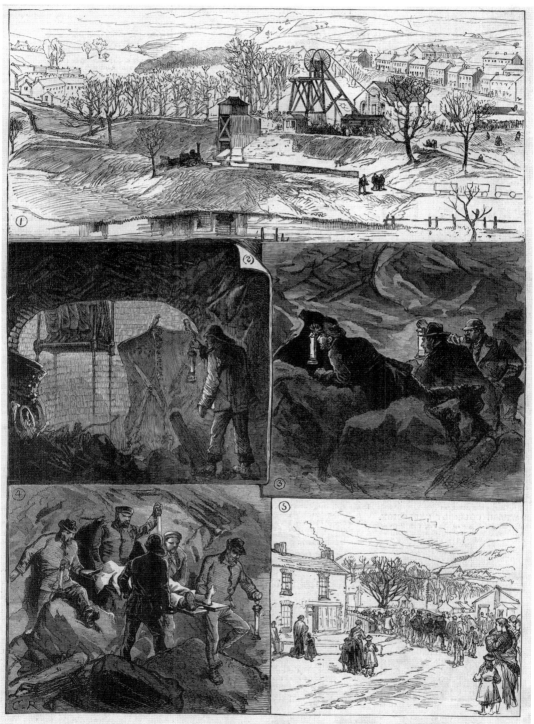

1. View of the Pen-y-Graig Colliery. 2. The Down-Shaft; explorers descending. 3. Explorers crawling between the fallen débris and the roof.
4. Bringing the dead to the bottom of the Shaft. 5. Carrying the dead through the village of Trealaw.

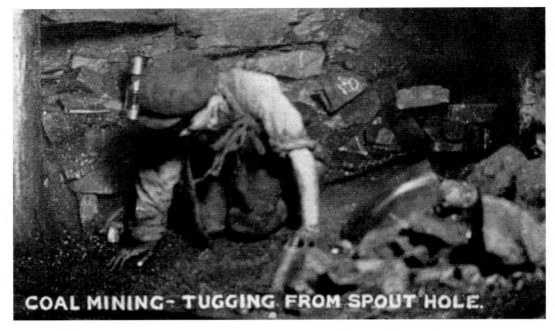

One of the young boys employed to open and shut air doors underground, *c*. 1900.

Troops billeted in the Rhondda during the Miners' Strike, 1910.

Rheola

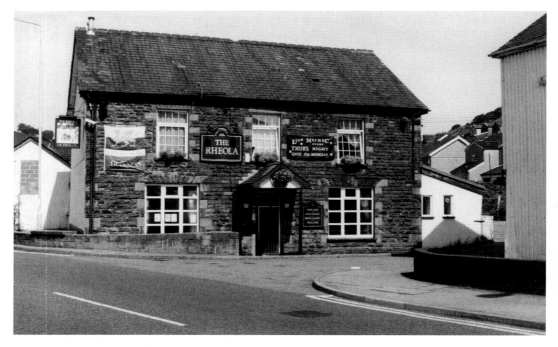

The Rheola inn (Vivian Stinchcombe)

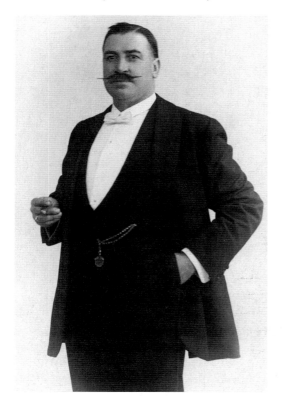

Left: Edgar Charles Powell, landlord of The Rheola inn, 1920. The photograph was taken by A. Davies, Royal Studio, Porth, Rhondda. Edgar Charles Powell was landlord of the White Hart Hotel in Pontypridd at the beginning of the twentieth century, moving to the Rheola Inn, Porth, just after the First World War and remaining there until retiring to Bridgend in the mid-1940s. Powell was a small-time boxing promoter, arranging bouts in the Rhondda and adjoining valleys, and was one of the sponsors of Jimmy Wilde. He was also a well-known local character who had interests outside the Welsh Valleys. Edgar Powell was the proprietor of a number of billiard halls in London, and was a frequent spectator at major boxing events in the capital.

Right: Margaret Jane Powell, landlady of The Rheola inn, 1936.

Margaret Jane Powell (née Harding) was the wife of Edgar Powell and landlady of the White Hart Hotel. Apparently she was the dominant partner of the two, and all the customers said that she definitely 'wore the trousers'. The hotel was opposite the station in Pontypridd. The premises is now a club, but the iron brackets from which the White Hart sign was hung are still evident. The Powells later moved on to become landlord and landlady of The Rheola hotel from around 1917 to 1947. Both are buried in the cemetery at Trealaw, Porth.

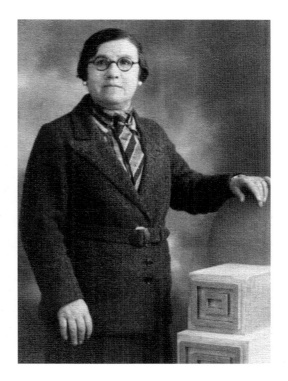

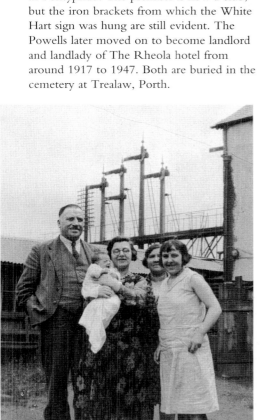

Left: The Powell family, 1931.

This photograph was taken in 1931 in the yard of The Rheola inn, Porth, Rhondda. From left to right: Edgar Charles Powell, daughter Lily Leonora Pringle (née Powell), wife Margaret Jane Powell and other daughter Ivy Powell. The baby held by Mrs Lily Leonora Pringle was her daughter, Margaret Jean Pringle. An extension to the premises has since been built in the yard immediately behind the group, and the railway which ran behind the hotel has been demolished, together with the signal gantry shown in the photograph. Land formerly occupied by the railway is now used as the hotel car park. All the adults in the photograph are buried in the Powell–Pringle vault in the cemetery in Trealaw.

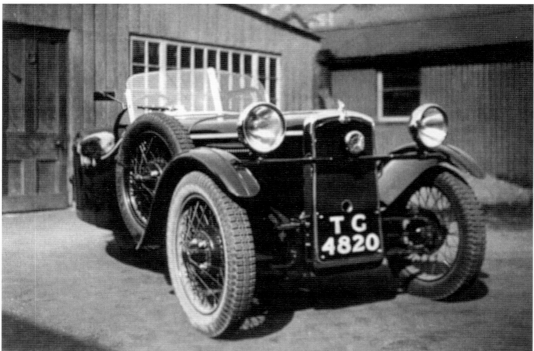

Margaret Jane Pringle, aged two, at the rear of The Rheola inn, 1932

Right: Dr Edgar Clifford Powell (Dr Cliff) with baby Margaret Pringle, his niece, at the rear of The Rheola inn, 1931. Dr Powell was the brother of the landlord.

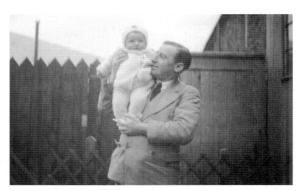

Below right: A four-year old Margaret Jane Pringle at the wheel of Dr Cliff's BSA car, 1934.

Opposite above: Antique sideboard and silverware from when the Powells were in residence at The Rheola inn, 1920.

Opposite below: Dr Edgar Clifford Powell's three-wheeled motor car, a BSA front-wheel drive, 1932

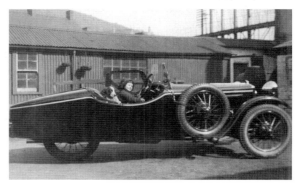

The Tynewydd Disaster, by Western Mail reporter, Morian

In April 1877, a thanksgiving service for the survivors of the Tynewydd disaster took place at the Rheola Inn. The men concluded that they had been on the verge of eternity, and death by drowning had seemed close at hand. The five begrimed Welshmen went on their knees, and Edward of Gelynog offered up prayer in his own ancient Cymric tongue, commending them all, in time and eternity, to the gracious mercy of God. The earnest prayer being over, Edward invited his companions to join him in singing a well-known Welsh hymn, singularly appropriate to the occasion. Here is the first verse of it:

> *Yn y dyfroedd mawr a'r tonau,*
> *Nid eos neb a ddeil fy mhen,*
> *Ond fy anwyl briod Iesu,*
> *A fu farw ar y pren;*
> *Cyfadl fy mhen yn uwch na'r don,*
> *Golwg arno wna I mi ganu,*
> *Yn yr afon ddofn hon.*

This in fact was, later in the day, communicated to the author by a Baptist minister named James, who afterwards left Pentre, Ystrad, to work in the missionary field in India. In the back parlour of Rheola Inn, we translated it into English, as well as we were able:

> In the deep and mighty waters,
> None there is to hold my head,
> But my dear Saviour Jesus,
> Who was doomed in my stead;
> He a friend in Jordan river,
> He'll hold my head above the flood,
> In His hand I'll go rejoicing,
> Through the regions of the dead.

Inquest, Rheola Inn, Porth, Thursday 4 May, 1877

The inquest on William Morgan, Edward Williams, Robert Rogers, John Hughes and William Hughes opened with Thomas Morgan giving evidence. The coroner was Mr George Overton of Brecon, and most of the evidence was given in Welsh. Morgan told of the first moments after the inundation and of joining up with Edward Williams and William Cassia. Moses Powell gave evidence about the long days of imprisonment.

The inquest was adjourned until 15 May when officials would be prepared to give their evidence. William Abraham (Mabon), the miners' leader, was present on this occasion. It was revealed that the plans of the pit were out of true to the extent of 16.5 yards. This error concerned the position on the top of the Dip, and all measurements taken from that point were wrong. David Rees, fireman, could not read or write. He had been fireman for the whole pit, but was now in charge of the Dip and the headings of Charles Oatridge, Edward Williams, George Jenkins and Edward o'r Maindy.

Twenty-five men worked in the Dip, and he was also responsible for the fire at the top of the Dip. Richard Howells, overman, was second in charge of the pit. He could not read or write English, but could read Welsh. He told the Court that the depth of water in the Gelynog Dip, measured perpendicularly, was 54ft. The five men had been trapped 48ft below the surface of the water. Thomas E. Wales, Inspector of Mines, quoted the Mines Regulations Act of 1872, pointing out that when nearing water or abandoned workings, the heading must be made 'in the narrow' and not more than 8ft wide. Boreholes 5ft long must be made ahead.

Verdict: 'We are of the opinion that the death of the five miners arose from the culpable neglect of the manager in not complying with the rules, and we return a verdict of manslaughter against him, but at the same time, we are of the opinion that the neglect arose from a mistake he made in expecting to meet a fault before he came to water'. James Thomas, Manager of Tynewydd, was committed for trial on a coroner's warrant. Bail was allowed in the sum of £200.

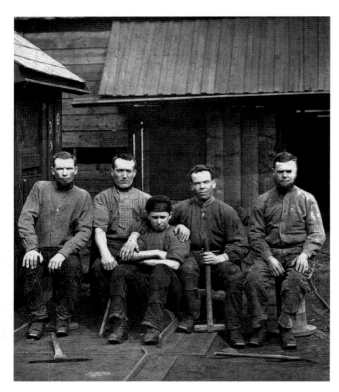

Tynewydd disaster survivors, from left to right: John Thomas, George Jenkins, David Hughes (the boy), Moses Powell, David Jenkins, April 1877.

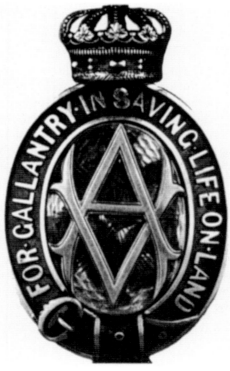

The Albert Medal awarded to the rescuers of the Tynewydd disaster.

seven

Sporting
Memories

Wilf Jones

Sportsmen Of Tylorstown Past And Present
Wilf Jones

The village of Tylorstown has produced many sportsmen down the years. In the boxing fraternity, the legendary Jimmy Wilde is probably the best known. Although he was not born in the area, it became his home town and he was known as the 'Tylorstown Terror' and 'the ghost with a hammer in his hand'. He fought many opponents heavier than himself and only lost four fights in his long career. Another local boxer was Billy Fry – they say he trained on a diet of fish and chips. Finally, there was a family of boxers – Teddy, Ivor, Lewis and Dickie Lewis. Dickie also played football for Tylorstown Albion in the early 1930s.

In the world of swimming, Mr Ivor Sutton (who lives in East Road), despite losing a leg at an early age, was not deterred from his sport. He played water polo for Darren Park: a sport that seems to have lost its popularity and was a Welsh international long-distance swimmer. After his more active days had ended, he formed the Rhondda Polar Bears: a water sports organisation for disabled people. Ivor now serves as a Justice of the Peace: a service well earned. In rugby, John Bevan started his career playing locally, and moved on to make a name for himself with Cardiff and Wales, before moving north and switching codes to play Rugby League for Warrington.

On the soccer scene, a former resident of Parry Street, Keith Burge, is a well-known referee who takes charge of matches in the English Premiership, as well as in Divisions One, Two, Three and Welsh matches. On the playing side, Robert Page (whose parents live in Vivian Street), a product of Tylorstown School, went on to make the grade with Watford and is a member of the Welsh international side. Then there's a FIFA linesman who also officiates at English Nationwide League games, Colin Jones, formerly of Brondeg Street. He has been acting as a linesman in more than a dozen countries, and has run the line at Wembley Stadium on three occasions, including the thrilling Rumbelows Cup final between Manchester United and Nottingham Forest on 12 March 1992. He now lives in Pontypridd and is a Police Inspector. His brother Kevin is a referee, serving the League of Wales.

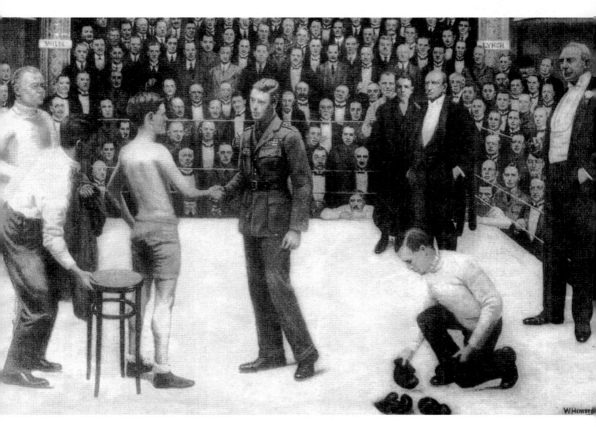

A proud moment captured on canvas: the legendary Jimmy Wilde is presented to the Prince of Wales before the memorable fight with Joe Lynch.

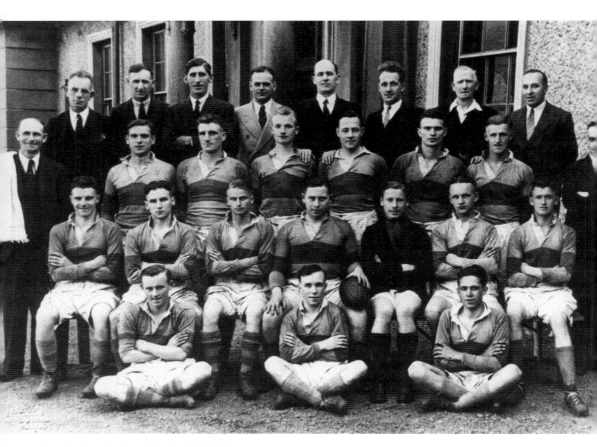

Llwyncelyn Welfare, Porth, 1937/38.

Opposite above: Porth Harlequins Rugby Football Club, 1900. From left to right, back row: H. Jenkins, H. Rees, D.L. Jones, A.J. Burge, W. Rees (vice-captain). Middle row: L.T. Davies (secretary), A. Ellis, J. Morgans, D.J. Jenkins, E.M. Jenkins (captain), S. Johns, D. Jenkins, J.H. Jenkins (treasurer). Front row: J. Rees, W.J. Evans, G. Jenkins, J. Griffiths.

Opposite below: Tonyrefail Secondary School RFC, 1945/46. Cliff Morgan is in the front row, fourth from left.

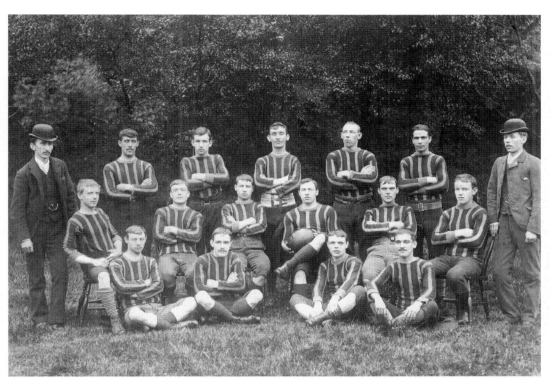

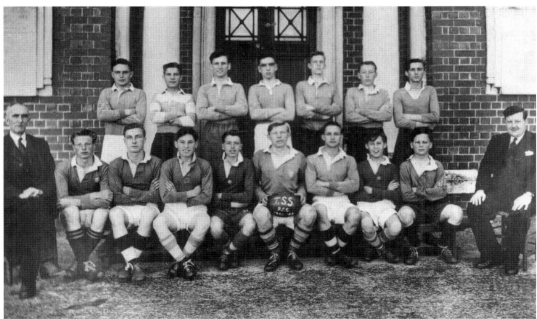

Griff John. If you mix a burning ambition to get into show business with a passion for rugby football and a most passable tenor voice, then you could be describing any one of a thousand men from the Rhondda. Combine this with a love of bowls and a regular Sunday stint as organist of his local Pisgah Methodist Chapel, and you will almost certainly be down to just one contender, Griff John. During his teens, young Griff had taken his singing lessons most seriously and, supported by his tutors, was having a love affair with the entertainment business. Sadly, the economic climate decreed otherwise and Griff was forced to seek employment elsewhere while his showbiz dreams gradually melted away. Only in Canada, was he able to pursue his two great loves – singing and sport. He also attained the peak of his rugby career when playing for Pontypridd for two years.

Right: Nineteen-year-old Percy Kingsbury (left), the day before he won the Army Shot and Javelin Tournament in Egypt, 1947. He is pictured with Colin Allison, cousin of Malcolm Allinson, the former Manchester City manager.

Left: Percy Kingsbury with the MBE Medal for Services in Sport to the Youth and Veterans of RCT, March 2002. Percy has trained over fifty British Champions.

Below: Official timekeeper for many sporting events, Mr Edmund Thomas of Pontygwaith. Thomas the Time worked as a collier and was also a soldier, an ambulance man, a mathematician, a philosopher and an accomplished violinist. This photograph was taken in 1973, when Thomas was aged eighty.

TWELVE TWO-MINUTE ROUND CONTEST.

LEN DAVIES

(SWANSEA). The crack Welsh featherweight who has boxed before at this Hall and will be remembered for his great fights with Warren Kendall and George Thomas. This will be his last appearance in the ring before his sidestake match with Sid Worgan. V.

DELWYN JOHN

(TREHERBERT). The younger of the famous boxing brothers, who has fought all the class London boys, and will more than test Davies.

SPECIAL EIGHT TWO-MINUTE ROUND CONTEST.

Pte. JOE GABICA

(NEWPORT). Who has recovered his form and done well in Army boxing. V

DON BUNDOCK

(TREHERBERT). The brilliant young Rhondda boy who makes his first appearance at this Hall.

SIX TWO-MINUTE ROUND CONTEST.

LES PHILLIPS v. KEN CARTER

(CWMPARC). This lad is a fighter and should be a good match for Carter.

(NEWPORT). This youngster has improved remarkably well as fans have seen during his display and win over Emlyn Tanner.

SIX TWO-MINUTE ROUND CONTEST.

RON COOK v. TOMMY JONES

(NANTYGLO). This is the K.O. specialist who has captured the fancy of Newport fans.

(TREHERBERT). A dour fighter from the home of boxing.

SIX TWO-MINUTE ROUND CONTEST.

Bryn COLLINS *draw* V. Vernon BALL

(NANTYGLO). The great youngster who is popular on any programme for his game display.

(CWMPARC). Another Rhondda boy and can be vouched to fight.

A promotional poster advertising the home of boxing, Treherbert, 1944.

eight

Schools

Education at Porth: 1880-1930

In the 1880s there were two groups of elementary schools at Porth: these were governed by school boards, whose boundaries met at Porth. The Llanwonno School Board were in charge of a group of schools to the north of the river, including Porth Boys' School, and the Girls' and Infants' schools. The Llantrisant School Board controlled the Cymmer group of schools, which were the only elementary schools at the beginning of this period.

The late Mr B. Davies was the headmaster of the Cymmer Boys' (or Mixed) School, and he laid great emphasis on his pupils learning the style of copperplate handwriting. Many of his old pupils, whose penmanship is to be admired, have borne testimony to the thoroughness with which they were taught this skill. Mr Dan Jones succeeded Mr Davies as headmaster, and remained in charge of the Boys' School for many years until his recent retirement. He is succeeded by Mr James Ashley.

At the Porth Boys' School, the late Mr Ebenezer Rees was the headmaster during the 1880s, having succeeded Mr Thomas. The writer has seen the government reports of this school while he was headmaster, and they were invariably very good and indicated thoroughly sound work. He was succeeded by Mr E. Samuel in 1889-1893, followed by Mr Abraham Williams, who had previously been in charge of the advanced class at the school. After his recent retirement, Mr Frank White was appointed his successor.

The Balfour Education Act of 1902 transferred the control of elementary schools to the local district councils, and this school came under the supervision of the Rhondda District Council. Within recent years, two large groups of elementary schools have been opened: namely Llwyncelyn School and the Islwyn School at Mount Pleasant. Mr William Howell is the headmaster of the latter, and Mr J. Hinton Jones was the headmaster of the former until he was succeeded on his retirement by Mr Owen Jones Owen.

The need for more advanced education was felt at Porth early in the 1890s. An advanced class was formed at Porth Boys' School under the care of Mr Abraham Williams, and through the energy and co-operation of the late Mr Idris Williams and the late Mr Henry Abraham, two local members of the Llanwonno School Board, this became a real success. However, the lack of suitable space and the growing number of elementary pupils caused the effort to lapse.

Because of the position of Porth, the Ystradyfodwg School Board established a Pupil Teachers' Central School here in 1893, and appointed Mr E. Samuel to the headmastership. This was a part-time school, at which those articled to the teaching profession were taught in sections on separate days. This continued for three years at the Bethlehem CM Vestry, Pontypridd Road. In 1896, Dr RD Chalke, MA, became the Headmaster, and the Pupil Teachers' School was later merged with the Higher Elementary School, Porth (now Secondary). The Intermediate Education Act (1889) allocated one intermediate school to the Rhondda, and there was great debate over the possible location of the new school. After much discussion, Porth – the gateway of the Rhondda Valleys – on account of its geographical position, succeeded in obtaining the school.

A three-acre area of land on the hillside above Mount Pleasant was donated by the late Colonel Picton Turberville, of Ewenny Priory, Bridgend. The school was opened on 22 September 1896 and the first headmaster was Mr E. Samuel, MA. On his retirement in 1925, he was succeeded by Mr E.D. Griffiths, MA. The school had its full complement of pupils right from the day of opening. It is a non-local school, and pupils from all parts of the Rhondda area and Tonyrefail attend. In 1913, the Girls' County School was opened, with Miss E.M. Harries, BA, as headmistress. There are now over 400 boys and nearly 300 girls attending these schools.

Later on, the school board established a Higher Elementary School at Mount Pleasant. The late Mr J. Grant, MA, was the first Headmaster, with Dr R.D. Chalke succeeding him. In recent years the school was elevated to the status of secondary school. After Dr Chalke's recent retirement, Mr Thomas Davis, BA, was appointed headmaster, thus Porth is especially favoured in the matter of secondary education.

E. Samuel, MA (Ex-Headmaster, Porth County School)

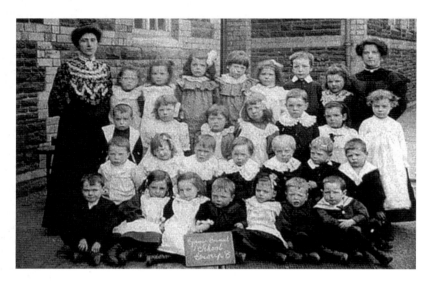

Cymmer Infants' School, 1908.

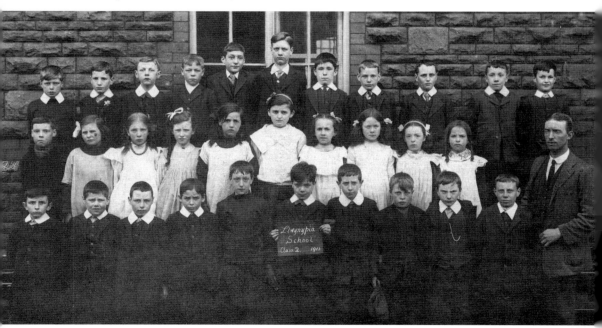

Class 2, Llwynypia School, 1913.

Trealaw Infants' School, St David's Day, 1946.

Trealaw Infants' School fancy dress party, 1948.

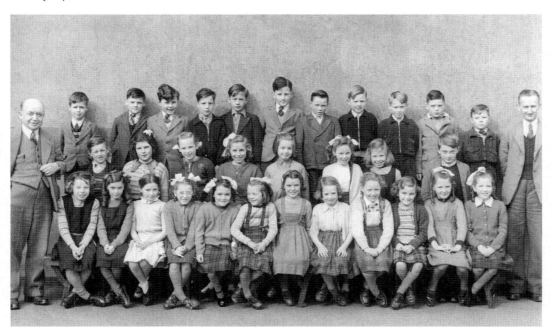

Trealaw Junior School, 1951.

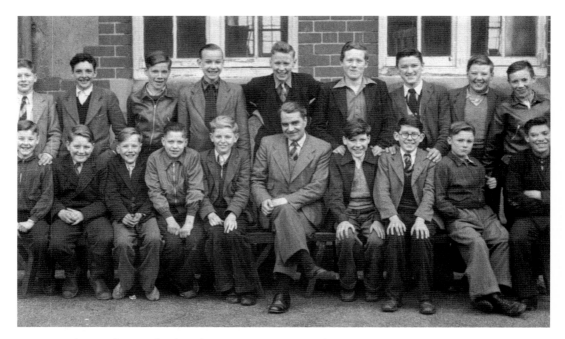

A science class at Islwyn School in the 1950s. Mr Davies is the science teacher, and Gary Kingsbury is pictured in the back row, second from right.

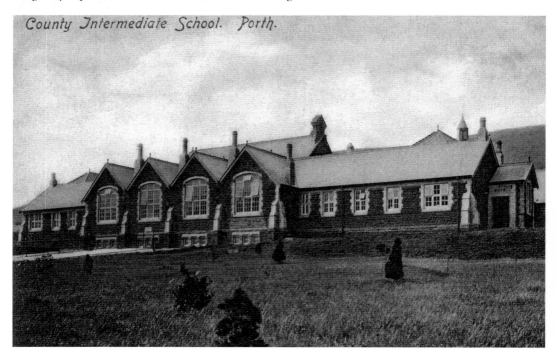

County Intermediate School. Porth.

Porth County Intermediate Boys' School, *c.* 1900.

Porth County Girls' School on a trip to Havingares, Paris, in 1954. Pat Edmonds (second from the right) is sat enjoying the French April sunshine with friends, La joie de vivre!

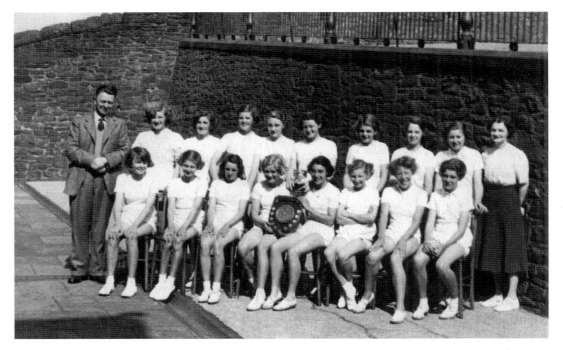

Llwyncelyn Secondary Modern Girls' Class, 1940s. From left to right, back row: Mr Birkett (teacher), Lena Ashford, Anita Rees, Pat Hopkins, Jean Evans, Pamela Davey, Maureen Apsen, Maureen Symons, Mair Thomas, Miss Harris (teacher). Front row: Mavis Edwards, Rita Robins, Joan Davies, Leah Jones, Alma Hill, Wyn McCarthy, June Davies (twin sister of Joan), Betty Griffiths.

When I was a Pupil Teacher
Richard M. John

My first school was Cymmer National (now occupied by Porth Pupil Teacher Centre), two miles down the valley: a long distance for a child of seven to walk daily and to attend service on Sunday (the condition of being a pupil). The penmanship of the headmaster, Mr Thomas Davies, was the talk of the district. 'Can't he write? ... Ain't he a scholar?' I owe him much for the interest he took in my early progress and remember with pleasure the two pupil teachers Packer and Jeffries.

I left that school with regret to enter one nearer to home, conducted by Mr William Evans, Billy the Factory or Billy the Weaver, as he was called. He had given up weaving for teaching. The school was held in a disused hayloft over a slaughter house. 'Aloft were hungry minds to fill, below fat animals to kill.' That master's habits were peculiar and his habits not always exemplary. I picture him seated with a class standing around his desk, his lame leg resting on a chair, a birch rod by his side and smoking away while the pupils shouted from *Vyse's Spelling Book*: 'a-b-a-n, aban-don, abandon'.

He went on smoking without heeding his pupils' unconscious advice. Some would look through the window into the adjoining field to enjoy an object lesson on their own account: the cattle grazing, or a couple of bulls, illustrating the use of horns as weapons of defence. The lesson might well be ended abruptly by the swish, swish, swish of Evans' pliant birch.

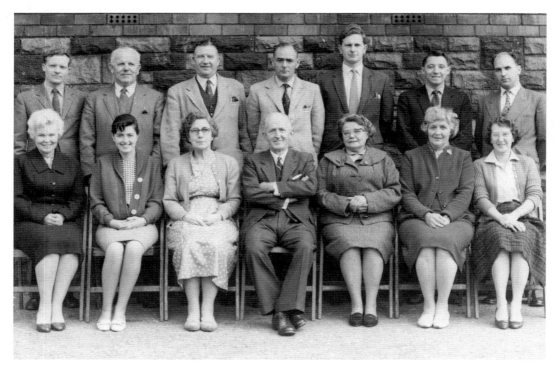

Trealaw Primary School staff. From left to right, back row: Mr Hitt, Mr D. Williams, Mr O. Griffiths, Mr Davies, -?-, -?-, Mr Snell. Front Row: -?-, Mrs Pat Edmonds, Miss Richards, Mr Evans (headmaster), -?-, -?-, -?-, 1960s.

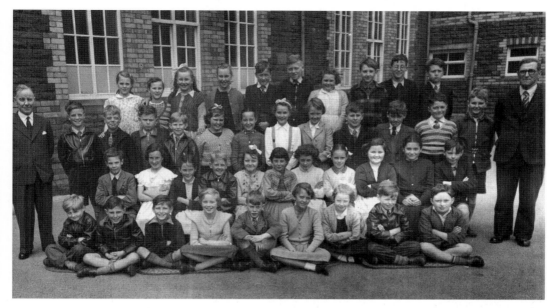

Standard 4A, Ynyshir Junior Mixed School, 1955. From left to right, back row: Margaret Howells, Lyn Foxwell, Tania Dyke, Janet Isaacs, John Corey, Clive Nicholas, Janice Davies, Lyn Price, Royston Edwards, Norman Venebles. Second row: Kenneth Ivins, Derek Chapman, Roger James, Rhoslyn Jones, Mary ?, Margaret Gould, –?–, Michael Stephens, –?–, Terence Godfrey, Paul Oaten. Third row: Gregory Hines, Daria Jones, Jennifer Roberts, Roland Roberts, Pat Price, Lyn Jones, Carolyn Jones, Wendy John, Jill Matthews, Susan Burden, John Nagle. Front row: Robert Deere, Philip Edmunds, John Palmer, Pat Bent, Raymond Griffiths, Mavis Hopkins, Merilyn Pearce, Terry Miles, Michael Matthews.

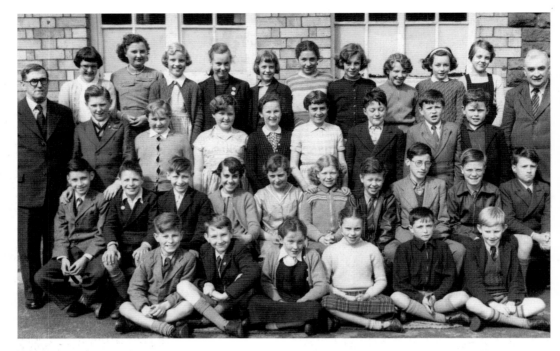

11+ Scholarship Class, Ynyshir Junior Mixed School, 1956. Includes in this photograph are: Michael Stephens, Ralph Jones, Maldwyn Atkins, Margaret Miles, Lyn Price, David Owen, Norma Spencer, Diane Llewellyn, Jennifer Roberts, John Palmer, Jill Matthews, Pat Bent, Wendy John, Susan Roberts, Lynne Foxwell, Janet Isaacs, Rosemary Giddings, Sheila Davies, Mavis Hopkins, Gareth ?, Brenda Jenkins, Terence Godfrey, Susan Burden, Rhoslyn Jones, Terry Miles, Brian Evans, Carolyn Jones, Royston Edwards, Roger James, Elaine Cotter, Kenneth Ivins, Linda Dowler, Norman Venebles, Margaret Howells. The teacher on left is Mr Thomas Walters and on the right is the head teacher, Mr Charles Evans.

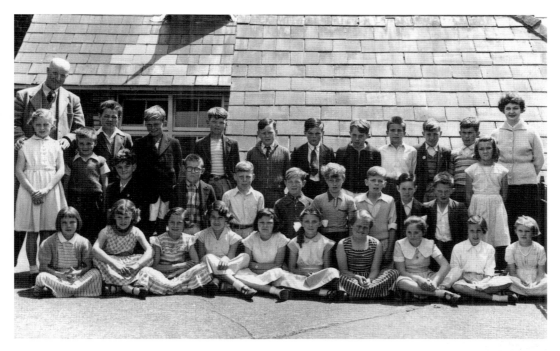

Trealaw Junior School, 1955.

Porth Secondary Grammar School in the Wye Valley, 1961. From left to right: Sheila Thomas, Linda Jones, Sheila Davies, Glynda Jones, Carolyn Jones, Janet Isaacs, Margaret Crewe.

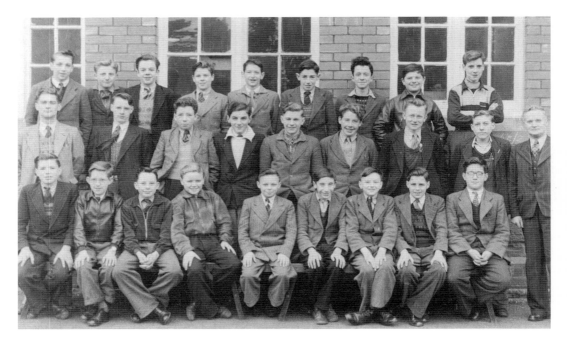

Standard 1 cricket team, Ferndale School, 1929.

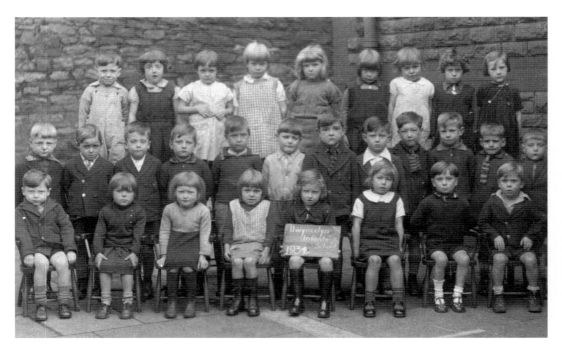

Llwyncelyn Infants' School, 1934.

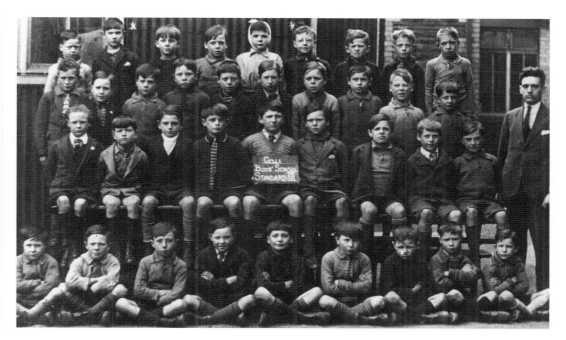

Standard 3, Gelli Boys' School, 1940s.

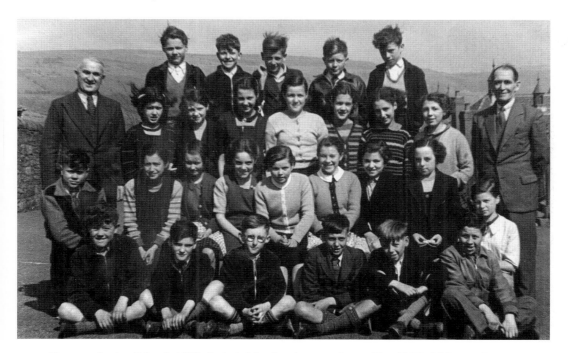

Cymmer Senior School, 1953. Included in the photograph are: Harold Hodgkinson, Ann Coleman, Jean Draisey, Mr Williams, Mr Fluck, Malcolm Thomas, Lena Oatridge, Anne Hammer, Maureen Boundford, Joyce Dunstone, Freddy Evans, Gerald Bowen.

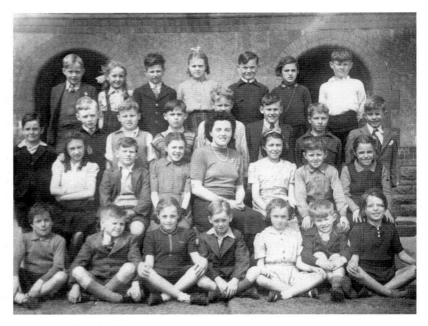

Islwyn School, Porth, 1946. From left to right, back row: Norman Challenger, Mair Hughes, Raymond Cheney, Myrna Watts, Wyndham Johnson, Marian Follet, and Gwyn Roberts; second row down: Brian Williams, Peter Williams, Michael Stephens, Alun House, Conway Jones, Ken Moon, Brian Rabbits, and Robert McLeish; next row down: Gill Morgan, Michael Isaacs, Olga Stone, Miss Thomas, Gwenda Smart, John Matthews, and Mair Savage; front row: Josephine Owen, Ivor Roberts, Ann Griffiths, Derek Williams, Barbara Williams, Martyn Lewis, Gwladys Smith.

The Italian Connection

The Italian Connection

The foundations of the Italian catering trade in Wales were laid in the 1890s and consolidated during the following decade. Amongst the first migrants to Wales, via London, were cousins Angelo and Giacomo Bracchi, pioneers of the ice cream and confectionary shops in South Wales and founders of the famous Bracchi Brothers chain. They opened their first café in Newport, but soon moved on Aberdare in 1894. Various members of the Rabaiotti, Berni and Pecis families had cafes and ice-cream carts on the streets well before 1907. Many pioneers, including the Sidoli brothers who arrived in the Rhondda Valley in 1906, recruited workers from Italy to help with their expanding businesses. The Bracchis established themselves so well that their name became part of a household phrase: 'Let's go down to the Bracchis'. And so it was that all other Italian cafés in the valleys of South Wales would be known as Bracchis.

Why are the cafés so historically important to the valleys of South Wales? When the Italians arrived in South Wales, little did they know that this was to be their home for generations to come. In the South Wales valleys, their cafés really flourished. Early trade was in cups of Oxo and Bovril, soft drinks and ice cream. Ice cream was made on the premises from fresh ingredients, using a hand-operated freezer. This was hard work, but by the 1930s, electrical refrigerators were available. Representatives of cigarette and chocolate manufacturers would dress the café windows. Inside there was often a large mahogany counter, with shelves and mirrors along the walls. The shelves would hold displays of glass ice-cream dishes and jars of expensive sweets. On the counter would stand huge marble soda fountains, with separate taps for each flavour of steaming cordial. The life pulse of the café would be the gleaming Vittorio Arduino coffee machine, which produced endless cups of tea and coffee and steamed pies.

The Italians brought a touch of glamour to the people of South Wales. The cafés provided many people with somewhere warm and friendly to go. Customers could stay as long as they wished and spend as little money as they liked. Many young couples did their courting in the cafés, and young men who had no homes to go to could spend their leisure time chatting and playing dominoes, cards, and on the penny-in-the-slot machines with other regular customers. Trade was particularly good at the weekend. Many of the shops were open every day until as late as 11 p.m., often only closing for a few hours on Christmas Day. In the coastal locations, the ice-cream parlours were successful. Elsewhere, individual Italians set up businesses selling snacks, confectionery and tobacco.

The following families opened cafés establishing their success: Cantavaggi, Canale, Fulgoni, Cresci, Figoni, Gambarini, Ferrari, Forlini, Tambini, Rossi, Ricci, Orsi, Viazzani, Melardi, Segadeli, Dimambro, Giovanoni, Copolo, Zanelli, Sidoli, Colombotti, Servini, Carpanini, Balestrazzi, Salvanelli, Chiappa, Forte, Assiratti, Malvisi, Minetti, Basini, Antonazzi, Opal, Minoli, Albertelli, Sterlini, Camisa, Vinagli, Poledri, Obertelli, Sartori, Pelopida, Strinati, Rinieri, Negrotti, Bacchetta, Belli, Valerio, Rea, Carini, Bracchi, Rabiotti, Cennamo, Tedaldi, Zeraschi, Fecis, Bertorelli, Franchi, Marenghi, Magerchpa and Minacca. The common factor with most of these family names is that they all came from the same area of Northern Italy – Bardi. It is hoped that one day St Fagans Museum of Welsh Life will set up an Italian café exhibition to record the café society culture that existed during the coal mining era of South Wales valleys.

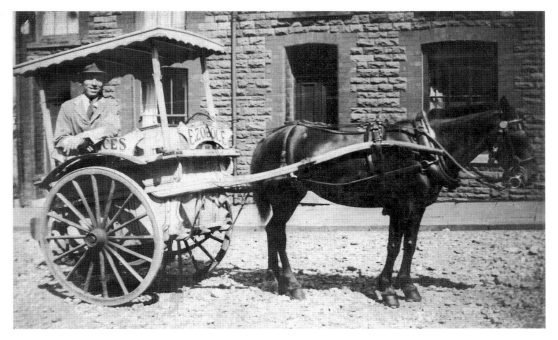

Mr E. Zobole and his ice cream cart on the streets of Ystrad, *c.* 1910. He was the grandfather of Ernie Zobole, the International Award Winning Artist who lived on Penrhys Hill.

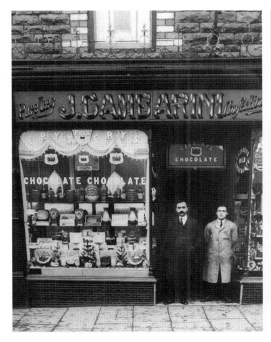

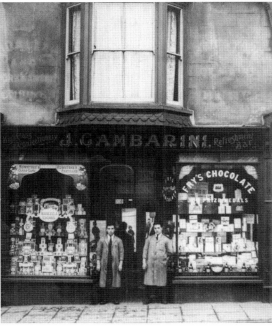

Joe Gambarini and his Italian assistant, at 20 East Street, Tylorstown, 1920.

Joe Gambarini's café, Tynewydd Square, Porth, 1930. This café also became Rhondda's first licensed restaurant in the 1950s.

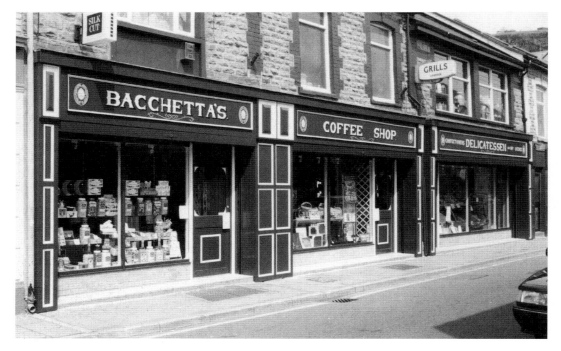

Bacchetta's at Nos 2, 3 and 4 Station Street, Porth, 1994. There was an Italian café museum located above No. 4.

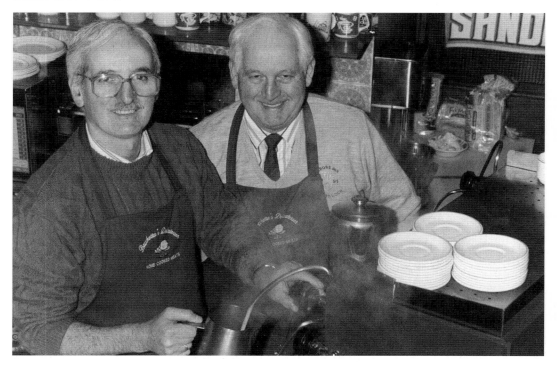

Ron and Aldo Bacchetta preparing the café for another busy day, 1990.

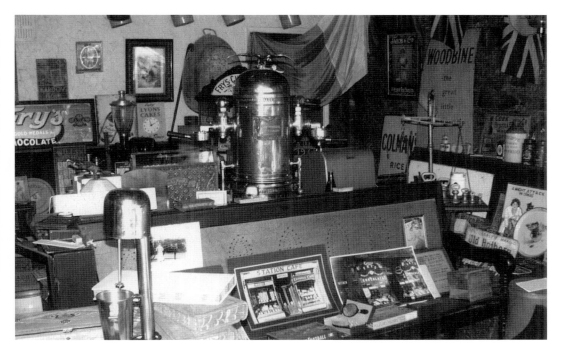

Bacchetta's Italian café museum, 1985.

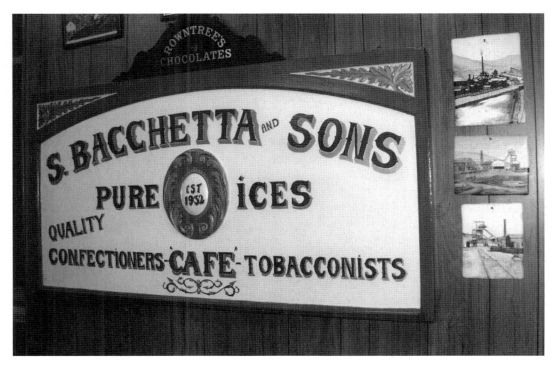

A café sign inside Bacchetta's, Porth. The café served the local community for seventy years.

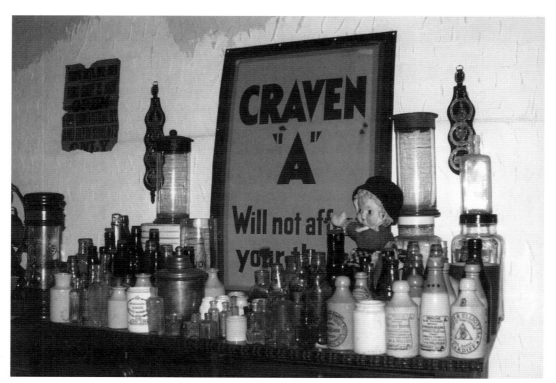

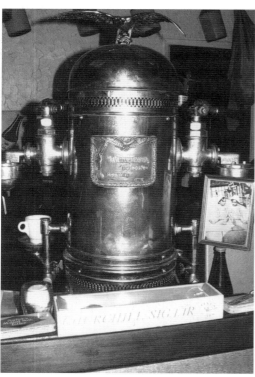

Fry's Chocolate, Edwardian display cabinet, 1920. Shown here are cigarette cards and tobacco tins, a Prince Edward VIII handkerchief and a King Edward VII chocolate box.

Right: A Victorian advertisement for tea and biscuits, 1900.

Opposite page
Above: Old sweet jars, mineral bottles and a cigarette advertisement: 'Craven A will not affect your throat'.

Below left: A Victorian coffee grinder from the 1900s. When in use, it would give out the beautiful aroma of fresh ground coffee.

Below right: La Vittorio Arduino Torino Italian coffee machine, 1910. This clever invention produced endless cups of tea and coffee for its day, and steamed up milk as well as producing the famous steam pies.

Above: A Bracchi ice cream dish from 1906 on display with a tobacco metal board game, some dominoes and Horlicks mugs from the 1950s.

Right: A model ice cream cart, with its A. Canale & Son advertisement, was to be seen working in Cwmparc, 1924. The family business is still carrying on today, thanks to Mario Canale and family.

Valley of Song

Tudor Davies, Operatic Tenor

Tudor Davies was born 12 November 1892 in Pen-y-Wern Cottage, which is No. 173 High Street, Cymmer, Porth. One of twelve children, he started to learn the violin at an early age; however, an injury to his hand prevented the continuation of his violin studies, which enabled him to concentrate on his singing.

Tudor Davies' father worked as a surface mechanic at Cymmer pit and was known affectionately as 'Gaffer Yard'. It was in the same pit that Tudor started his working life but, with the generosity of the miners and neighbours who recognised the outstanding abilities of the young Tudor, enough money was collected for him to start his studies at Cardiff before moving on to the Royal College of Music in London, under Gustave Garcia.

During the First World War, Davies served with the Royal Navy for four years. When the war finished, he continued his studies and became Principal Tenor with the then British National Opera Company, performing as the lead tenor in seven world premieres. He was also a founder member of the Vic-Wells Opera Company, under the direction of Lilian Baylis.

Tudor Davies is one of the very few Welshmen ever to have sung at the Metropolitan Opera House in New York. He toured the United States extensively, and also visited Australia twice and Canada on four separate occasions. At Covent Garden in 1921, he made his debut on the first night of the season as Rodolfo in *La Bohème*, and in 1922 repeated his role, singing Rodolfo opposite Nelli Melba's Mimi. In 1923 he created the part of Hugh the Drover in Vaughan Williams' opera of the same name at His Majesty's Theatre. In 1924-25 he sang the first performance of Holst's *At the Boar's Head*.

In 1941 Davies married Ruth Packer, a brilliant soprano – her vocal quality and dramatic intensity were akin to that of her husband's, and she remained his loving companion until his death. At the height of his career, his voice may not have had the talent of Caruso, but they had one thing in common: it was an earthy directness of vision, expressing itself through a vocal tone of natural resplendence.

Tudor Davies sang a wide range of roles with the Sadler's Wells company, and later with Carl Rosa, until his retirement from opera in 1946. His voice was described as having incisive tone and lively temperament. He died in 1958 and was buried in Monmouthshire.

Left: Unveiling a plaque outside the birthplace of Tudor Davies, 173 High Street, Cymmer, now the home of Mr and Mrs John Bunyan. The two ladies pictured are Mair Bunyan and her mother, Elsie Hopkins.

Above: Empire Music Stores, was especially tailored for choirs and orchestras made sure that everyone interested in music had access to all they might need.

Gwyn Thomas, Writer and Broadcaster

Gwyn Thomas was born in Cymmer, near Porth, on 6 July 1913. He was the youngest son of an unemployed miner and was one of twelve children. His mother died when he was still a small child and his eldest sister, Nana, brought up the family. Educated at Porth County Grammar School, he won a state scholarship to Oxford to read Modern Languages in 1930. In 1933, with the aid of a state scholarship provided by the Miners' Fund, he spent six months at the University of Madrid, during the exciting days of the short-lived second Spanish Republic war.

After graduating in 1934, he worked for four years as a WEA lecturer associated with the Maes-yr-Haf Settlement at Trealaw, and it was this period that helped to bring out the novelist in him. He himself would often mention this source of inspiration in his many BBC recordings and novels. Many of his plays and stories feature the Rhondda Terraces during the Depression of the 1930s. Groups of unemployed friends would meet in the institute or the library or the Italian café, where they woud listen to records of Italian opera or have fierce socialist discussions.

By the late 1930s, the Rhondda started to recover and employment started to increase, which helped Thomas to sharpen his satirical wit. Both as a scholar and as a prolific writer, he made his mark by being very entertaining and it was his talent for performing that drew him irresistibly before the microphones and the cameras along with the likes of celebrities such as Richard Burton, Jack Hylton, Stanley Baker, Sam Wanamaker, Harry Secombe, Gilbert Harding, Lady Barnet and Donald Houstan. This new life robbed him of the time he needed to write the plays and novels his admirers were waiting for after the promise of his earlier works.

Nothing could change his love of the Rhondda Valley (where he had been born), the people and their struggle to survive the hard times that the coal-mining community had to face. This also helped to fire his imagination and to capture the spirit and the humour that made his style of writing and dialogue so unique. He was once described as one of the greatest talkers in the world, and he had a tremendous versatility taking part in BBC Radio's programme, *The Brains Trust*, an online news satire, and many documentaries. Gwyn Thomas died in 1981, having been, through the media, one of the most well-known Welshmen of his time.

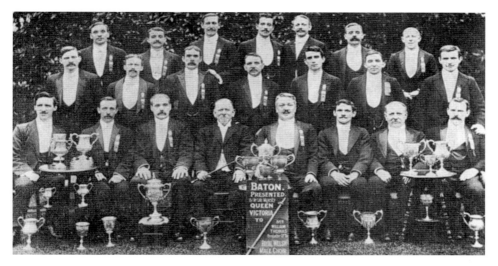

The Royal Welsh Male Choir and their conductor William Thomas at Windsor Castle, 29 November 1895. Singing here before Queen Victoria, they then continued their success through touring America in 1906, and Australia, New Zealand and South Africa between 1909 and 1910.

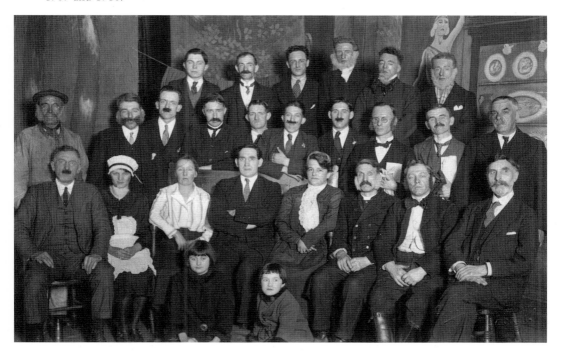

Dramatic society, Saron Chapel, Ynyshir, 1935.

The Royal Welsh Male Voice Choir with pianist Mary Carpenter Edwards, *c.* 1960.

A Rhondda Operatic Society production of *The Mikado*, 1930.

Right: Mr Vic Oliver conducted the British Concert Orchestra and the Rhondda Opera Chorus in the 1950s.

Below left: A night out at the opera. Sid Bacchetta and lady companion on his right, with Mr and Mrs Salvanelli and Mrs Virginia Basini (seated) on the right, 1939.

Below right: Dressed up in his top hat and tails, Mr John McGlory (Burlington Bertie) of Aberrhondda Road, Porth, 1930.

Two year old Jode, granddaughter of Glyn Howells of Park Crescent, Porth, sitting on Glyn's great-uncle's bardic chair. Mr Edward Edwards from America Place, Porth, worked his passage to the USA and won this magnificent chair in 1875 at the Pittson Pennsylvania Eisteddfod. Cadair Trodynfab, the chair awarded for poetry.

People

Porth post office, 1940s. Once one of the hubs of the community, Porth post office was the first main depot in the Rhondda and also the Rhondda's first telephone exchange. This fine building still stands and is soon to be re-opened as a café bar.

Left: Mrs Shirley Hanks of Tonyrefail, formerly Miss Shirley Keates of Edmondstown was the carnival holiday princess in July 1951, aged fifteen.

Below: Feeding the sheep at Maendy Farm, Pentre, January 1940.

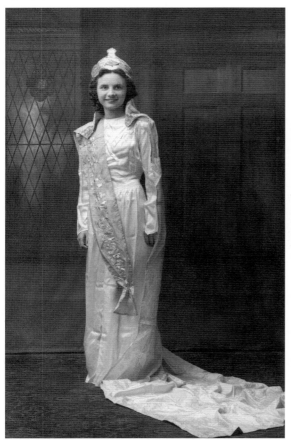

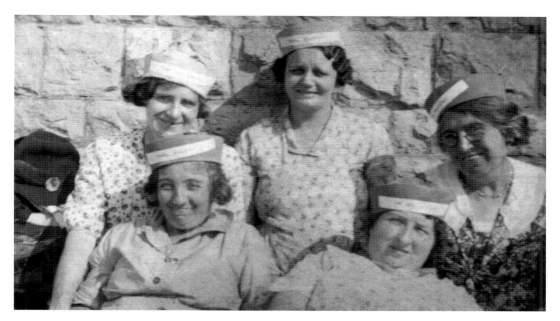

Girls from Ynyshir having a good time at Barry Island. Enid Hanks (top row) is the sister of soldiers William and David Morgan.

Giulia Bertorelli's twenty-first birthday party, 1960. The picture includes: Mr and Mrs Davies, Giulia Bertorelli, Mrs Bertorelli, Angelina Antonelli, Severio Delapino, Massimo Abzetta, Dom Balestrazzi, Celia Bertorelli, Lui Balestrazzi, Domenica Bracchi, Teresa Merlardi, Adreanna Carpanini, Rita Franchi, Anna Cruci, Rita Cavalli, Romeo Basini, Mrs Servini, Tony Strinati, John Rabiaotti, Mario Tuscanny, John Cruci, Mario and Ron Bacchetta.

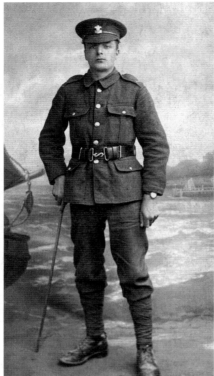

Private William
John Morgan (left)
and Private Isaac
David Morgan
(right), brothers of
Enid Hanks from
Yorkshire.

In Loving Remembrance of

Private William John Morgan
(13th Welsh)

The beloved Son of Mr. and Mrs. William Morgan,
5 Weston Terrace, Ynyshir,

Who was Killed in Action in France by a Shell,
On the 14th January, 1916,

Aged 20 Years,

Interred somewhere in France, January 14th, 1916

Dros ei Dduw, a'i wlad fe roddodd
William John ei fywyd—clyw,
Ac yn Ffrainc ei gorph orphwysa,
Nes atseinia udgorn Duw:
Ar y maes yn ddewr-ddyn syrthiodd,
Do, yn aberth dros ei wlad,
Ond ei enaid a orphwyso,
Yn mharadwys,—ty ei Dad.

"For all flesh is as grass, and all the glory of man as
the flower of grass. The grass withereth, and the flower
thereof falleth away."—1 PETER 1. 24.
"Therefore be ye also ready: for in such an hour as ye
think not the Son of man cometh."—MATT. 24. 44.

"GONE BUT NOT FORGOTTEN."

In Loving Remembrance of

Private Isaac David Morgan
(No. 24610, 13th Welsh Regiment)

Beloved Son of Mr. and Mrs. William Morgan,
5 Weston Terrace, Ynyshir,

Who died in Munster, Westphalia, Germany,
September 20th, 1917,

Aged 21 Years,

Dros ei Dduw, a'i wlad fe roddodd
William John ei fywyd—clyw,
Ac yn Ffrainc ei gorph orphwysa,
Nes atseinia udgorn Duw:
Ar y maes yn ddewr-ddyn syrthiodd,
Do, yn aberth dros ei wlad,
Ond ei enaid a orphwyso,
Yn mharadwys,—ty ei Dad.

"For all flesh is as grass, and all the glory of man as
the flower of grass. The grass withereth, and the flower
thereof falleth away."—1 PETER 1. 24.
"Therefore be ye also ready: for in such an hour as ye
think not the Son of man cometh."—MATT. 24. 44.

First World War
memorial cards
for the Morgan
brothers, 1916.

638 LAA Royal Artillery Pentre Division at Camp Bude, Cornwall, 1952.

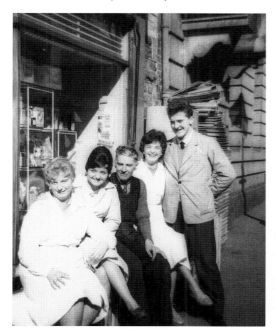

Boots Chemist, Station Street, Porth, in the 1950s. From left to right: Barbara Vercoe, Gillian Walby, Ivor Mumpford, Millie Watkins, Paul Servini.

Chief dispenser at Boots Chemist, Millie (Ball) Watkins, 1950.

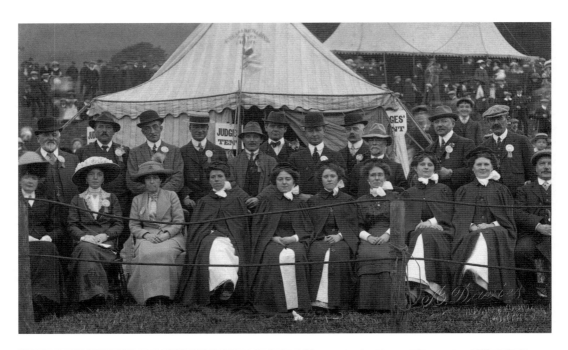

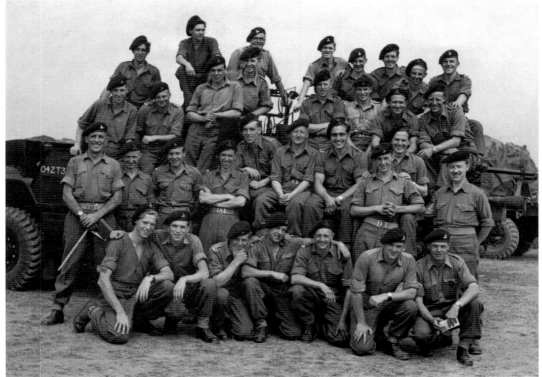

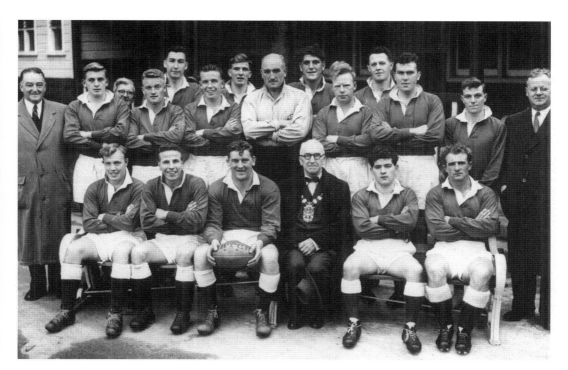

Lord Mayor Councillor, L. Rothero, RBC, with the 1st Rhondda Combined RFC team, 1957. Included in the photograph are: Reg Edwards (trainer, Tylorstown), Gwyn Lewis (Penygraig), Tom Morgan (Treherbert), Ike Merry (Tylorstown), John Griffiths (Tylorstown), Gareth Bailey (Penygraig), Ron Green (Treherbert), Ossie Bevan (Penygraig), Mr George (referee), Don May (Tyorstown), Bernard Gully (Tylorstown), Roy Woods (Penygraig), Bertie Jones (Penygraig), Denis Taylor (Ystrad), Arthur Hull (Treherbert), Tiger Philips (Treherbert) Percy Kingsbury (Tylorstown), Councillor Mr Elias.

Opposite above: Doctors, nurses and judges at a charity sports gala to raise money for the Miners' Welfare, Tynycymmer estate, Porth, *c.* 1900.

Opposite below: Pentre Division 638 LAA Royal Artillery on manoeuvres in Bude, Cornwall, 1952.

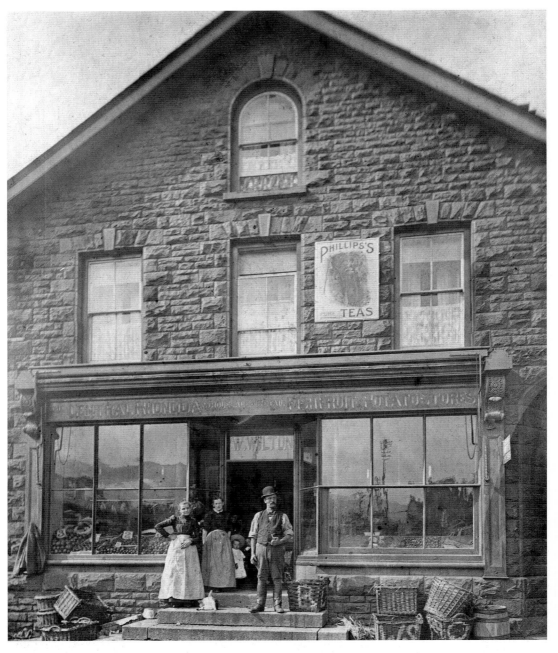

Mr Wilton's fruit and potato store, 1900. This property was later to be converted into a public house, The Fighting Blood, across the road from The Rheola inn.

Left: Gwendoline Thomas and her great-grandson, Peter John Daley, Trehafod, 1892. Peter was aged four, his great gran was seventy-nine. She was locally known in Trehafod as Gwenny the Cwrt because of the fact that her cottage at 19 Coedcae Road was used by the visiting magistrate to try minor crimes. Her son Jenkin went – as foreman to Sir William James Thomas of Brynawel House (owner of Standard Pit), Ynyshir – to search for gold in Ballarat, New South Wales. Whilst there, Jenkin married a Scottish girl, Agnes, who was the daughter of a squatter. They had three children together, two boys and a girl – the girl Mary was the eldest and she was the mother of Peter.

Below: Festival of Britain fancy dress competition, 1951. Included in the photograph are Giulietta Camisa, Kay Smale, Giulia Bertorelli, Jean Draisey and Cynthia Rogers.

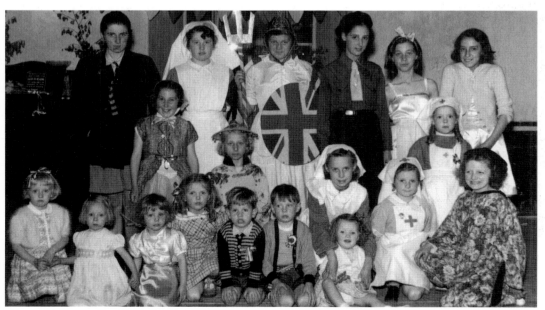

Other local titles published by Tempus

Porth and Rhondda Fach The Second Selection
ALDO BACCHETTA AND GLYN RUDD

In this book, the pre-eminence of coal and mining in the local economy is apparent, the early history of this once great industry is chronicled, the influence of religion on the everyday is considered and stoicism in the face of great adversity shines through. Communities covered include Porth, Cymmer and Trehafod, Tylorstown, Ferndale and Maerdy. All those who share the pride the Rhondda inspires will be delighted by this fascinating collection.
0 7524 1135 7

Folklore of Wales
ANNE ROSS

Full of rich and varied folklore, this book looks at legends associated with place-names, calendar customs, giants, monsters, witches, ghosts, supernatural birds and animals, folk healing and herbal remedies. Every lake has its legend, giants stalk the land, fairies can be dangerous and hostile, omens of potential marriage partners are avidly sought, and ghostly death-lights - corpse candles - can be seen moving relentlessly towards the person doomed to die.
0 7524 1935 8

Glamorgan County Cricket Club Classics
ANDREW HIGNELL

This book traces the history of the Glamorgan CCC through fifty particularly memorable encounters. From minor county matches at the end of the nineteenth century through to the great triumphs of the year 2000, the games chosen can all be deemed 'classics'. With a foreword by Steve James, the 2001 county captain, and writing by the club's statistician and historian, Andrew Hignell, this book will stir up both memories and debate.
0 7524 2182 4

South Wales Collieries Volume IV
DAVID OWEN

This fourth volume of South Wales Collieries covers the central valleys of Merthyr, Glamorganshire, to the eastern valleys of Rhymney, Sirhowy, Ebbw and Afon Lwyd, including Big Pit at Blaenavon, a World Heritage Site and location of the National Mining Museum of Wales. It illustrates the area's industrial history during the past two hundred years and gives a glimpse of both working and village life in the valleys.
0 7524 2879 9

If you are interested in purchasing other books published by Tempus, or in case you have difficulty finding any Tempus books in your local bookshop, you can also place orders directly through our website

www.tempus-publishing.com

or from **BOOKPOST**, Freepost, PO Box 29, Douglas, Isle of Man, IM99 1BQ
tel 01624 836000 email bookshop@enterprise.net